IMAGES
of America

MISSION HILLS

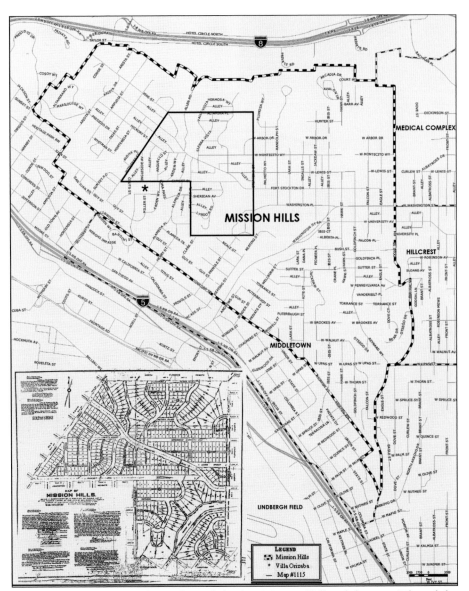

In 1908, George Marston's syndicate formed the first Mission Hills subdivision. The subdivision name embraced the region's history, and its layout rejected a grid street pattern. Marston put John Nolan's 1908 "San Diego: A Comprehensive Plan for its Improvement" into practice, including using the topography of the land to articulate the street patterns. Over time, Mission Hills Two and Three were formed and adjacent subdivision names were forgotten. Now, a much larger area is culturally identified and recognized as Mission Hills. (Courtesy of senior planner Marlon Pangilinan, City of San Diego.)

ON THE COVER: Around 1925, an unidentified man admires the unique architectural features of the houses along the north side of Fort Stockton Drive just west of the intersection with Hortensia Street in the Fort Stockton Line Historic District. The original part of Mission Hills was subdivided on January 20, 1908, and developed as a streetcar suburb. The architectural styles in the neighborhood represent a diverse range of the design aesthetic from the early 20th century. (Courtesy of Bruce and Alana Coons.)

IMAGES
of America

MISSION HILLS

Allen Hazard and Janet O'Dea

ARCADIA
PUBLISHING

Published by Arcadia Publishing
Charleston, South Carolina

Printed in the United States of America

Library of Congress Control Number: 2014910312

For all general information, please contact Arcadia Publishing:
Telephone 843-853-2070
Fax 843-853-0044
E-mail sales@arcadiapublishing.com
For customer service and orders:
Toll-Free 1-888-313-2665

Visit us on the Internet at www.arcadiapublishing.com

*We dedicate this work to those who came before us and
those who choose to preserve our sense of place.*

CONTENTS

ACKNOWLEDGMENTS

We would like to thank our generous friends, neighbors, and folks from far and near for contributing their families' photographs and giving their time to help compile the images for this book. While many photographs are undated, they all helped us to visually represent the beginnings of the delightful way of life found in the Mission Hills community. This book would not have been possible without them. We would also like to thank visitors to the Historic Mission Hills Facebook page, as those interactions encouraged us to embark upon this endeavor. We want to particularly thank the following for their numerous contributions to this work: Francis W. Parker School; the United Church of Christ (UCC); the Mission Hills Methodist Church (MHMC); Irene and Merril Miller Jr.; Tom Sandler of the Frame Station for finding images of the former Ford dealership and reframing old original photographs for us; City of San Diego senior planner Marlon Pangilinan for assistance with the official Mission Hills map; Patty Brookes for promoting our search for local images in the *Presidio Sentinel* newspaper; Paul and Sarai Johnson for help with scanning a very large image of St. Vincent de Paul church; Erik Hanson; and Bruce and Alana Coons. We would also like to acknowledge the inspirational work of the Save Our Heritage Organisation. It is a passion for the sense of place that has inspired us to become involved in the preservation of San Diego and the vibrant Mission Hills community. We are grateful to Alyssa Jones, our acquisitions editor and representative from Arcadia Publishing, for her enthusiasm of this work, guidance, and assistance with many items. Thanks go to our families, friends, and wonderful neighbors for your moral support and interest. Unless otherwise noted, all images appear courtesy of the authors.

INTRODUCTION

The story of Mission Hills begins with three seminal figures—Sarah Johnston Cox Miller, Kate Sessions, and George Marston.

Miller's stepfather, Capt. Henry Johnston, was the captain of the SS *Orizaba*. The *Orizaba* was a wooden side-wheel steamer, nicknamed the "*Mayflower* of the West." Johnston steered the ship up and down the California coast, bringing newcomers to San Diego. In 1869, Johnston bought 65 acres on a high plot of land above San Diego Bay, in what would eventually become Mission Hills. He died before building his dream home there. In 1887, his stepdaughter Sarah Miller filed a subdivision map for Johnston Heights, and in 1888 she built a magnificent Victorian house, known as the Villa Orizaba.

In 1903, after losing her Balboa Park lease, Kate Sessions, horticulturalist and "Mother of Balboa Park," and her brother Frank began buying up property in what was then known as North Florence Heights to establish her nursery business. She chose land near West Lewis Street and Stephens Street for both her nursery and growing grounds, because of the rich soil, moist sea breezes, and remote location. They built lath packinghouses at the north end of Lark Street, relocating them a few years later to where Ulysses S. Grant Elementary School lies today. From these sites, poinsettias were grown, packed, and shipped throughout North America. In 1922, Sessions sold the nursery to Giuseppe and Pasquale Antonicelli, and the Antonicellis moved the nursery to its current site on Fort Stockton Drive in 1925.

Around 1905, George Marston, a prominent businessman and progressive civic leader, brought John Nolan to San Diego to develop the first city plan; however, the city never adopted the Nolan Plan. The plan did provide a development guide aligned with the City Beautiful Movement of the late 19th century and resonated with Marston.

Meanwhile, Percy Goodwin and others organized a syndicate to buy 60 acres adjoining the north end of Sarah Miller's property (along modern-day Sunset Boulevard) for $36,000. On January 20, 1908, Marston, along with family members Tom and Charles S. Hamilton, Hotel Del Coronado developer Elisha S. Babcock, John Kelly of Kelly Investment Company, and coinvestors John F. and James D. Forward, filed Subdivision Map No. 1115, composed of 22 acres. They called their new subdivision Mission Hills, reflecting Nolan's ideals that San Diego embrace its "romantic history . . . and give happy recognition to its topography." The location was close to the original site of the San Diego Presidio and the 1769 Mission San Diego de Alcalá, known as the birthplace of California and Plymouth Rock of the Pacific. Marston's syndicate hired Frank A. Rhodes to survey the land and New York landscape architect George Cooke laid out the tract. Cooke used the principles from Nolan's plan, such as following the topography of hilltops and deep ravines for streets and leaving canyons undisturbed for the purposes of recreation, scenic enjoyment, and open space. There is a hierarchy to the street pattern. Queen palms were planted along Sunset Boulevard to "dress the street . . . but avoid shading the homes."

The early developers intended to make Mission Hills one of the most exclusive neighborhoods in San Diego. It was a restricted subdivision, requiring that homes cost at least $3,000 to build, when the average worker earned $10 per week. At the time, the area was mostly barren, with the exception of a citrus grove on Trias Street, olive and lemon orchards on Fort Stockton Drive and Jackdaw Street, Calvary Cemetery (now buried within Calvary Pioneer Memorial Park), Kate Sessions' nursery, and a few dairy and chicken farms.

Street names in the original Mission Hills subdivision reflected San Diego's early history. Fort Stockton Drive references the old US Army fort at nearby Presidio Hill, from the Mexican War. Sierra Vista, Valle Vista, Hermosa Way, and West Montecito Way reflect Nolan's vision that topographical descriptions "express themselves in the soft words of the Spanish language." Portola Place is named after the Spanish explorer Gaspar de Portolá; Couts Street pays homage to the wealthy 19th-century landowner Cave Johnson Couts; Cosoy Street was named after the Native Americans that lived below Presidio Hill; Altamirano was named after members of an important Spanish pioneer family; Arguello was named after Santiago Arguello, a former Californio and alcalde (mayor) of San Diego; Bandini is named after Juan Bandini, a prominent Old Town leader; Witherby was named after a prominent local judge, and Sheridan Avenue after the Civil War Union general. A literary reference is represented by Arden Way, supposedly named after a forest in Shakespeare's *As You Like It*. Other streets were named after trees, such as Palmetto, Pine, and Hickory Streets.

In 1907, Sessions and Alice Rainford sought support from John D. Spreckels, the owner of the San Diego Electric Railway Company, to extend the electric trolley line from First Avenue to Washington Street. Although Sessions's new growing grounds proved to be fertile, she found that the location was too remote for her customers. In 1908, Sessions succeeded in convincing Spreckles to extend the route No. 3 trolley line, and by 1909 it stopped at West Lewis and Stephens Streets, right in front of her nursery.

In September 1909, Johnston Heights was subdivided again by Harry L. Miller, the son of Sarah Johnston Cox Miller, and renamed Inspiration Heights (map No. 1212). Inspiration Heights was a more appealing name, and promotional materials were designed to attract newcomers. The old street names of Johnston Avenue, Dunkirk Avenue, Jerome Avenue, William Street, and Leverett Street were renamed Sunset Boulevard, Orizaba Street, Bandini Street, Alameda Drive, and Loma Pass.

The 1909 announcement for the 1915 Panama California Exposition drew builders from around the country to San Diego, creating a building boom that started in 1912 for Mission Hills and lasted through World War I, with the area mostly developed by the time the United States entered World War II.

By 1909, several houses were built in the area: the Willis and Florence Ehrlich House, a pebble-dash stucco bungalow built by Powell and Fogg at 1836 Sunset Boulevard; the Cheney-Stevenson Craftsman designed by Emmor Brooke Weaver at 1816 Sheridan Avenue; and the John H. Ferry Craftsman at 4204 Randolph (unknown builder). It is believed that in 1908, L. Eugene Fuller started to build his Dutch Colonial home after a handshake deal with Percy Goodwin. Fuller was a carpenter and mechanical engineer. By 1909, the Fuller residence at 1815 Sunset Boulevard was well underway.

During the early 20th century, most of San Diego's important architects designed or built houses here, including notables such as Frank P. Allen Jr., Edward Depew, Henry Lord Gay, William E. Gibb, Louis Gill, Del Harris, William S. Hebbard, William Templeton Johnson, Walter Keller, Henry J. Lang, Cliff May, Frank Mead, Henry Preibisius, the Quayle Brothers, Robert Raymond, Richard Requa, Lillian J. Rice, William Wahrenberger, Emmor Brooke Weaver, and William Wheeler Sr. Notable master builders were represented also, including David Owen Dryden, Richard Hathaway, Ralph Hurlburt, Morris B. Irvin, Wayne McAllister, Martin V. Melhorn, Parkinson & Parkinson, Nathan Rigdon, Alexander Schreiber, Charles Tifal, and Frank O. Wells. Talented builders such as Chester Eastman, John S. Graves, Robert Hall Orr, Edward L. Rambo, as well as building companies such as the Pacific Building Company, A.M. Southard Building Company, Trepte Builders, and others constructed distinctive Mission Hills homes of fine craftsmanship. Many of these builders lived in Mission Hills as they worked, including Graves, Irvin, Johnson, Melhorn, Requa, Rigdon, Schreiber, Wheeler Sr., and later, during building infill projects, Samuel Hamill and Modernist architect Homer Delawie.

The architecture of Mission Hills ranges from vernacular to spectacular. Styles include bungalow, Craftsman, Prairie School, Mission, and Spanish Revival designs. The Midwestern Prairie School,

popularized by Frank Lloyd Wright and his contemporaries, had a profound influence upon the physical appearance of Mission Hills. There are over 50 Prairie School houses in Mission Hills, more than in any other San Diego community. Builders Nathan Rigdon, Morris B. Irvin, Joel E. Brown, Alexander Schreiber, Martin V. Melhorn, Joseph Burness, and Harry L. Turner embraced a San Diego version of the Prairie School style. This indigenous, American style embodies a horizontality that seems to be an outgrowth from the earth. Following World War II, there was a significant shift in architectural designs as Delawie, Hamill, Henry Hester, Frank Hope Jr., Frank Liebhardt, Lloyd Ruocco, Sim Bruce Richards, and John Lloyd Wright built Modernist homes on the remaining available land, usually along the steep hillsides or in the canyons.

During the early 20th century, many leading artists and civic and business leaders called Mission Hills home, including freeway builder Roscoe E. "Pappy" Hazard; Rough Rider Capt. Thomas Rynning; tuna industry magnate Wiley Ambrose; District Attorney Stephen Connell; Catholic bishop Charles F. Buddy; San Diego mayors Percy Benbough and John F. Forward Jr.; store owner Guilford Whitney; attorney Ralph Jenny; plumbing contractors Fred Heilbron and Calvin Powers; Kate Sessions, her brother Frank, and her nephew, landscape architect Milt Sessions; State Sen. Edwin Sample; mortician Claude Woolman; Arthur Hay, the grandson of John H. Hay who served in the McKinley and Lincoln administrations; capitalist Edward Guymon; aviation pioneer T. Claude Ryan; journalism magnate Col. Milton McRae; as well as middle class residents such as dairy farmer Fred J. Allen; boxer, tavern owner, and father to San Diego mayor Maureen O'Connor, Jerome "The Kid" O'Connor; and the family of future state senator James Mills.

Several Mission Hills residents had a connection to the Chicago Prairie School, including Clara Sturgis Johnson, founder of the Francis W. Parker School; artist Orlando Giannini, who was associated with Frank Lloyd Wright; John Lloyd Wright; and Clara Barck Wells, retired founder of Kalo Shops and Arts and Crafts silversmith.

Mission Hills became a progressive and artistic community. Indeed, artists such as architectural critic and writer Eloise Roorbach; musician Alice Barnett Price Stevenson; poet John Vance Cheney; singer Augusta F. Sample; painters Hope Mercereau Bryson and Belle Baranceau; muralist Orlando Giannini; Bertha Bliss Taylor; the White Bungalow writers group; and the Hillside Artist Colony all took residence here.

The 1912 Mission Revival Rigdon and Italianate Montclaire apartment buildings became the centerpiece of the West Lewis commercial district. Powers Plumbing was established in 1914 downtown by Luther B. Powers. In 1917, Powers Plumbing moved the shop to West Lewis Street, and in 1923, commissioned Martin V. Melhorn to build a Spanish Revival building on the corner of West Lewis and Stephens Streets.

Along Washington Street, the 1912 Griswold Building and the 1927 Spanish Revival Florence Apartments anchored local businesses. Some remember the 1952, modernized Mission Hills Shopping Center as an important shopping center for the community with a Piggly Wiggly, Ace Drug Store, and about 20 other businesses—recently restored to the original style.

Mission Hills has three churches and three schools. Clara Sturgis Johnson came to San Diego from the University of Chicago. She followed the progressive educational philosophies of Col. Francis W. Parker, and in 1912, she established the Francis W. Parker School. Her husband, architect William Templeton Johnson, designed it. In 1914, Ulysses S. Grant Elementary School opened and was a beautiful Mission Revival building, which was demolished in 1974; it awaits another major remodel.

Around 1909, the Mission Hills United Methodist Church was established in a small, old wooden building at the corner of Falcon Street and West University. In 1914, needing a larger space, architect William E. Gibb designed a Mission Revival church at Lark Street and Fort Stockton Drive, which cost $13,500 to build. It features outstanding art glass from the Los Angeles firm Judson Art Studio.

St. Vincent de Paul Catholic church was built in 1910 as a Mission Revival structure at Hawk Street. The original church was demolished in 1968. The Mission Hills Congregational Church, now the United Church of Christ, began in 1911 in a redwood board-and-batten bungalow chapel

along Fort Stockton Drive and Jackdaw Street. In 1921, Louis Gill designed a larger modern Craftsman-style church.

Mission Hills would play a role during World War II, with many residents doubling up with Navy personnel due to a housing shortage. Many locals worked at nearby Consolidated Aircraft. Balboa Park was taken over for military training during the war, so the Fine Arts Gallery temporarily moved to the 1912 Milo C. Treat Mansion (demolished) on Sunset Boulevard.

Mission Hills is in proximity to two parks rich in San Diego history. To the west lies Presidio Park, originally home to the Kumeyaay people. In 1769, the Spanish built a presidio and the first mission, Mission Basilica San Diego de Alcalá. In 1907, George Marston, appreciative of the importance of the site, purchased the land to preserve it. In 1925, he began to develop the park and had William Templeton Johnson design the Serra Museum. In 1929, he donated the land to the City of San Diego.

Fr. Antonio Ubach was the "Last of the Padres." In 1866, he arrived in San Diego from Spain and was in charge of the Catholic parish. In 1873, he dedicated Calvary Cemetery, where thousands of Catholics were laid to rest, including Old Town pioneers such as Cave Johnson Couts, the Altamirano and Serrano families, Juanita Wrightington, and aviation pioneer Charles Francis Walsh. Father Ubach was also laid to rest here along with other Catholic priests, over 60 Civil War veterans, those in the potter's field, and about 200 infants. Burials continued until 1960. Though the markers were removed, this site remains a burial ground for thousands. Parts of the 1939 WPA adobe wall that once surrounded the cemetery can still be observed today. In 1970, Calvary Pioneer Memorial Park was established after the city closed Calvary Cemetery, removed the headstones, and developed it as a park, leaving the bodies to rest for eternity.

Mission Hills continues to be a community that celebrates its rich architectural heritage. The romantic name Mission Hills set it apart from other subdivisions that were often named after the developer. By the 1950s, there would be 53 named subdivisions in what is now generally referred to as the community of Mission Hills. Locals value the graceful old houses, and businesses thrive here. Many historical sites have been lovingly restored and preserved. In 2007, the City of San Diego designated Mission Hills and Fort Stockton Line Historic Districts, which include over 175 buildings. In June 2014, ninety-nine additional homes were added to the Mission Hills Historic District. The dynamic community ambiance embodies a unique sense of history and its romantic beginnings at a depth that is appealing to natives, newcomers, and visitors alike.

One

ROMANTIC BEGINNINGS

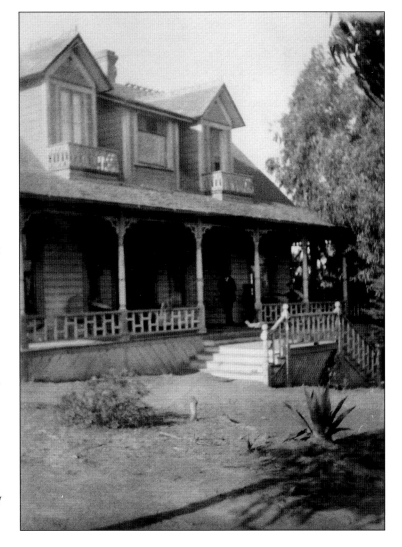

In 1889, the Villa Orizaba became the first house built west of Sixth Avenue. The elegant Victorian home was painted red with green trim. It had a gable roof and an iron-picket widow's walk. The interior featured the saloon sideboard salvaged from the SS *Orizaba*. Around 1908, this magnificent house was remodeled and transformed into a Prairie School house before Harry Miller's family took possession. (Courtesy of Irene and Merril Miller Jr.)

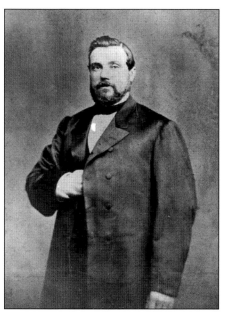

In 1869, Capt. Henry James Johnston, skipper of a wooden side-wheel steamer, the SS *Orizaba*, bought about 65 acres of land on a promontory above San Diego Bay in what would eventually become Mission Hills. He shared his vision with his family, but he died in 1878 before he could realize his dream of building a home in San Diego. (Courtesy of Irene and Merril Miller Jr.)

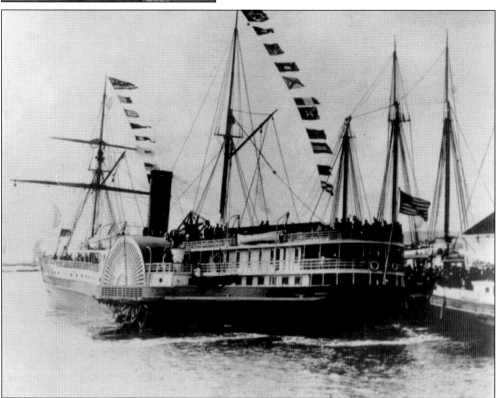

This 1880s photograph shows the SS *Orizaba*, built in New York in 1854. The side-wheeled steamer was called the *Mayflower* of the West because it ferried passengers between San Diego and San Francisco. Captain Johnston purchased the land that he saw each trip as he made his way into San Diego's harbor while aboard the vessel. In 1887, the ship was dismantled. (Courtesy of Irene and Merril Miller Jr.)

Born in 1844, Sarah Johnston Cox Miller was the stepdaughter of Capt. Henry Johnston. Sarah was educated in San Francisco and married George W. Miller. In 1887, she filed a subdivision map for Johnston Heights adjacent to what would become Mission Hills. In 1907, Sarah died having never profited from the land; in 1909, her son Harry re-subdivided and renamed the area Inspiration Heights. (Courtesy of Irene and Merril Miller Jr.)

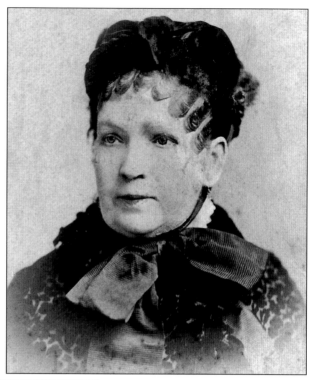

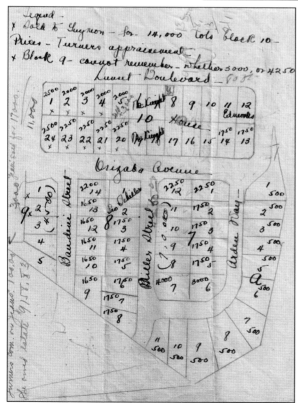

The 1909 Inspiration Heights lot records show the blocks, lot numbers, and prices. The lots with ocean views were more costly. The word "House," center right of Block 10, marks the position of the Villa Orizaba. Edward Guymon's future house was also built on Block 10, consisting of 10 lots and costing $14,000. Orizaba Avenue was named after Captain Johnston's old steamer ship the SS *Orizaba*. (Courtesy of Irene and Merril Miller Jr.)

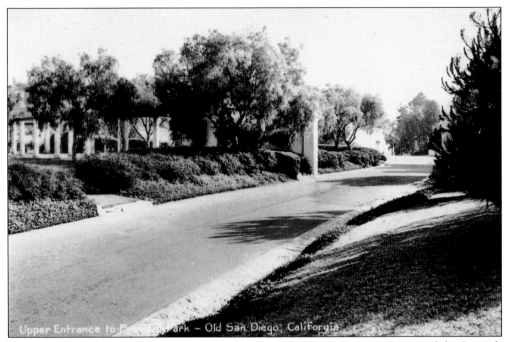

The first Alta California mission, established by Spanish friar Fr. Junípero Serra and the Spanish soldiers who resided on Presidio Hill, fascinated wealthy department store owner George Marston. In 1907, Marston bought the historic site and developed it into a park. He intended the park to be a tribute to the missionaries, soldiers, sailors, priests, and artisans who settled on the hill in 1769. The photograph captures the pergola and entrance monuments that face east towards Mission Hills.

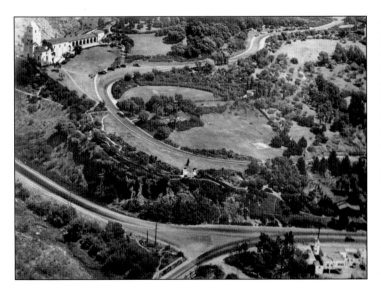

Pictured here is Presidio Park that George Marston had the foresight to preserve and develop before he gave it to San Diego. The 1929 Serra Museum is in the upper left corner (and is confused by some with the original mission). Marston stated that tending to the park was the largest work of his life. The boundaries of the original Presidio (fort) lie mostly within the 1930s adobe walls.

This is a 1909 caricature of Percival "Percy" Goodwin, president of the Mission Hills Company. He was also president of Hercules Cement Company, which laid the sidewalks along the 1800 block of Sunset Boulevard. Goodwin was associated with the syndicate that purchased 60 acres to the north of Sarah Johnston Cox Miller's property, which became part of the original 1908 Mission Hills subdivision.

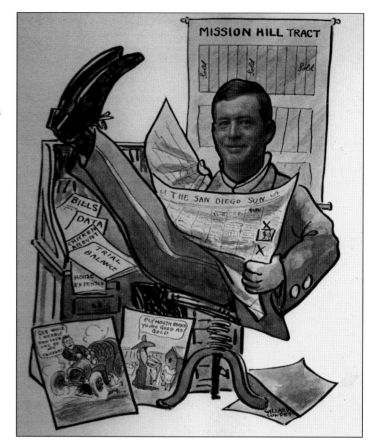

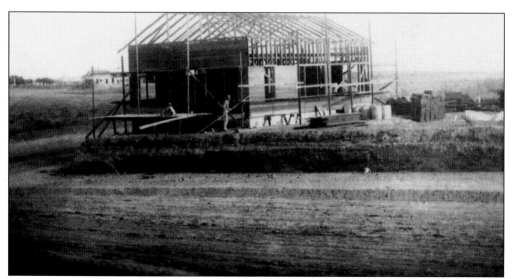

The 1908–1910 L. Eugene and Caroline Fuller House at 1815 Sunset Boulevard is seen here under construction. This was one of the first lots sold in the original Mission Hills subdivision and one of the first homes to be built. Fuller paid $2,000 for two lots and likely built the house himself. The 1912 city directory lists Fuller's occupation as carpenter. (Courtesy of the Zollman family.)

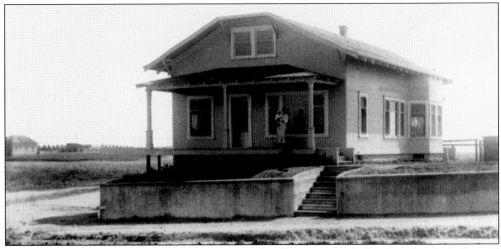

This photograph shows the finished Dutch Colonial Fuller House with Caroline Amelia Fuller and a child on the front porch. The house in the background lies across the canyon, just outside the original 1908 Mission Hills subdivision. Caroline's husband, L. Eugene Fuller, became a member of the International Workers of the World (IWW) or "Wobblies." In 1912, the IWW was involved in free speech protests in San Diego. (Courtesy of the Zollman family.)

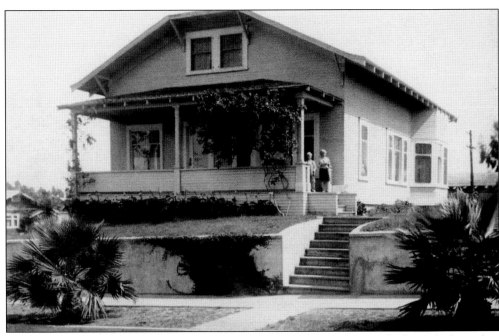

L. Eugene and Caroline Fuller had three children—L. Eugene Jr., LeRoy, and Olive. The bungalow to its left is the 1913 Jerome C. Ford House on Sheridan Avenue. The Ford house was the site of many Methodist Church meetings prior to the construction of the 1915 United Methodist church on Lark Street and Fort Stockton Drive. (Courtesy of the Zollman family.)

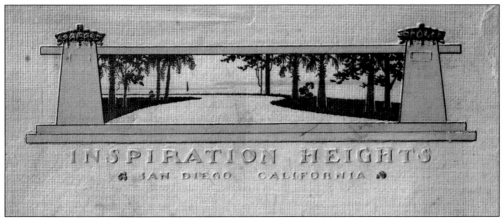

The front cover of a 1909 Inspiration Heights marketing brochure features palm trees and a halcyon view. Captain Johnston's grandson Harry L. Miller recruited a real estate development team to build four model homes along Sunset Boulevard. Promotional materials and letterhead depict the romantic notion of living in the community with vistas looking out to the sea. There were originally four pillars along Sunset Boulevard to mark the entry into Inspiration Heights; however, only three remain today. (Courtesy of Irene and Merril Miller Jr.)

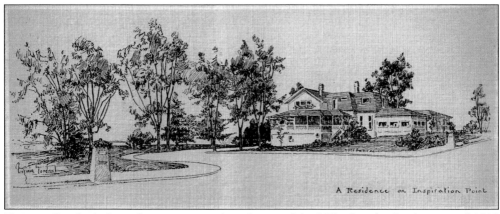

Virginia Goodrich drew this romanticized rendering of the Villa Orizaba for the original 1909 Inspiration Heights promotional brochure. The Victorian originally faced Sunset Boulevard before it was reoriented to face south. The curving street is Arden Way. The Inspiration Heights entry pillar on the west side of Arden Way and Sunset Boulevard was placed in the rendering but was never actually built. (Courtesy of Irene and Merril Miller Jr.)

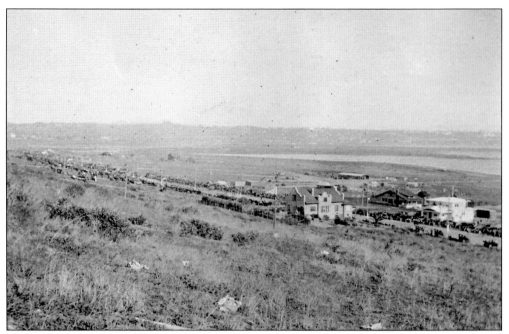

This early-1910s photograph captures Middletown from Middletown Addition, commonly referred to as "South Mission Hills." The view is looking south towards the San Diego Bay and Dutch Flats. A few early homes and buildings were constructed in the Middletown Addition subdivision, including the Mission Revival, Craftsman, and Prairie School houses pictured here. (Courtesy of Karen B. Jacobs.)

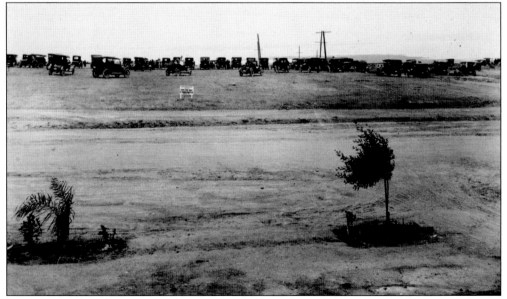

In 1919, crowds gather to view the visiting US Navy Great White Fleet in the harbor. Sunset Boulevard is the unpaved street in the foreground, originally named Johnston Avenue in this portion of what was once known as the Johnston Heights subdivision. In 1909, the street was renamed Sunset Boulevard to connect with the street name given to it by the Mission Hills Company. In 1921, the Guymon House was built on this site. (Courtesy of Janed Guymon Casady.)

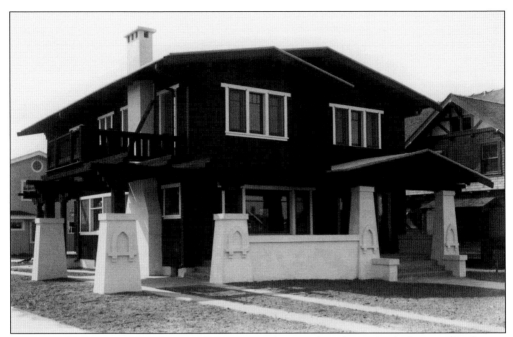

Master builder Martin V. Melhorn and carpenter John J. Wahrenberger built this 1912 Craftsman at 1905 Sunset Boulevard. They constructed three other Craftsman houses on Sunset Boulevard to showcase the Inspiration Heights subdivision. Notice the stylized motif on the cast concrete piers. (Courtesy of the San Diego History Center.)

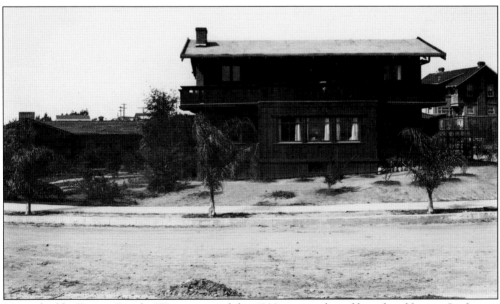

Master builder Emmor Brooke Weaver erected this 1909 rustic redwood board-and-batten Craftsman at 1816 Sheridan Avenue for the famous poet John Vance Cheney. In 1926, prominent singer Alice Barnett Price married Dr. George Stevenson and moved here. During the 1920s, the house was a meeting place for local and national musicians and singers, and the San Diego Symphony was formed here. (Courtesy of the San Diego History Center.)

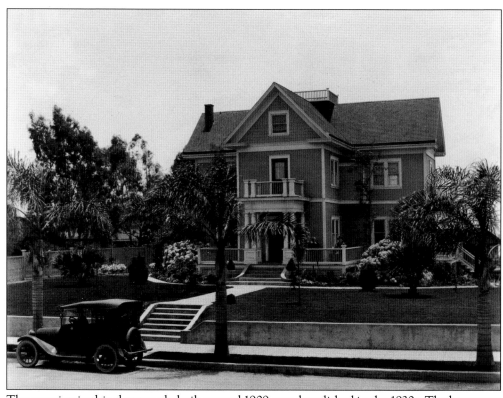

The mansion in this photograph, built around 1909, was demolished in the 1930s. The house was constructed for attorney P.H. Casey and his family, with the address first listed as 215 Sheridan Avenue. By 1915, Louise Casey was a widow, and by 1921, the house was sold to John and Helen McNeil. As of 2014, a portion of the fence marking the original property line still stands. (Courtesy of the San Diego History Center.)

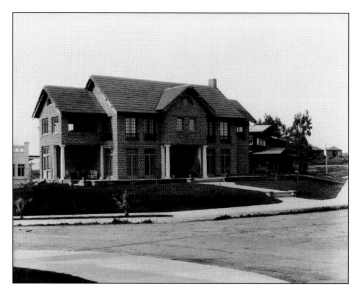

Walter Keller designed this 1913 Colonial Revival home for Alfred Morganstern, a top criminal-defense attorney. Keller was killed in battle during World War I. In 1918, Morganstern sold the home to Ralph E. Jenney, a federal district judge and president of the Fine Arts Society (Museum of Art). This symmetrical facade has a brick veneer, high-hipped roofline, and multiple French doors. (Courtesy of the San Diego History Center.)

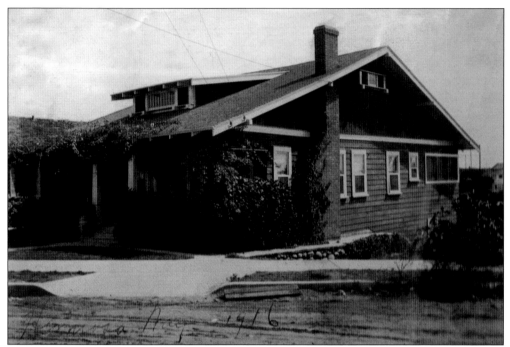

This Craftsman bungalow at 4355 Hermosa Way was built around 1913. Burt D. and Mary A. Stimson lived here with their daughter Mary Louise. The Stimsons were likely the first residents of this house. Burt was a confectioner who worked at 932 Fifth Avenue downtown. This photograph shows the river rock foundation, shiplap siding, and shingles above the course line. (Courtesy of Erik Hanson.)

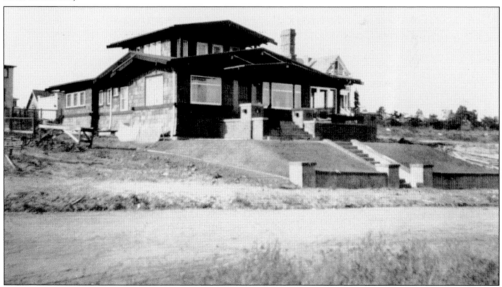

William Wahrenberger designed this 1914 Shingle Style "airplane" bungalow for Minnie and Clinton Brainerd. In 1915, Clinton died. Minnie later married her neighbor Jerome C. Ford, a retired lumberman and moved from this house to Ford's home around the corner. The interior featured iridescent Steuben glass shades and a tortoiseshell-tile fireplace. The Casey mansion can be glimpsed in the background of this photograph. (Courtesy of Bette Farnsworth.)

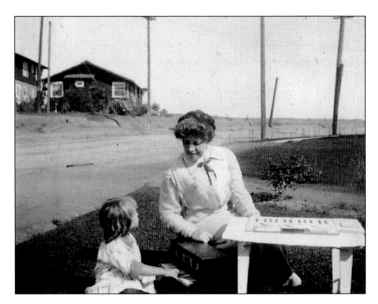

Around 1913, a Mrs. Hawley gives little Mary Louise Stimson music lessons in front of 4355 Hermosa Way. The streets were still dirt, and Mary Louise attended nearby Francis W. Parker School. By 1917, the family had moved to 232 Cedar Street, and Burt Stimson listed his profession as foreman. By 1922, Burt was a manager for the First National Bank Building downtown. (Courtesy of Erik Hanson.)

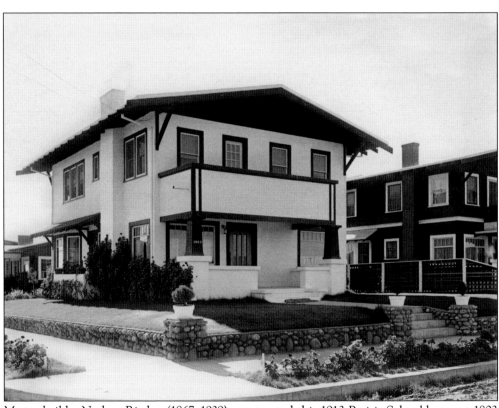

Master builder Nathan Rigdon (1867–1939) constructed this 1913 Prairie School house at 1803 West Montecito Way. Rigdon arrived in San Diego around 1909, and he lived at 1800 Fort Stockton Drive and was credited with building over 75 houses in Mission Hills. His version of Prairie School houses were labeled "Mission Hills Boxes." This facade has undergone significant change. (Courtesy of the San Diego History Center.)

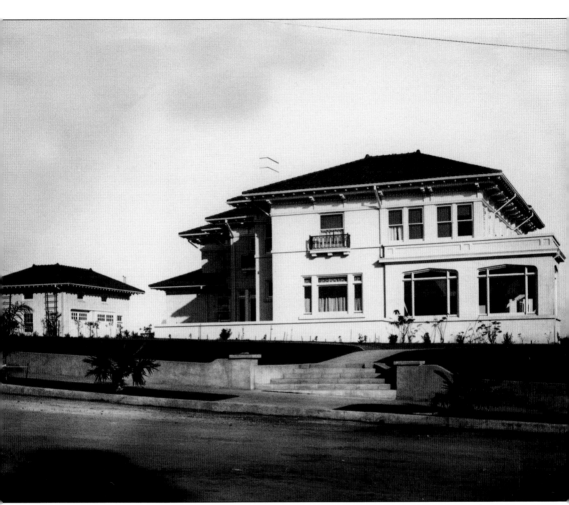

Local builder Edward Rambo erected the 1912 Milo C. Treat Mission Revival mansion for $40,000 along Sunset Boulevard. In one of the great losses for San Diego architecture, it was demolished in the 1950s and replaced by three houses. One of them was built by Modernist architect Lloyd Ruocco and one was built by Ruocco in partnership with Homer Delawie. The Treat Mansion covered most of the block and was originally advertised to be one of the most artistic and attractive homes in the city. From 1916 to sometime in the 1930s, Edith Williams and her seven children, a boarder, and a gardener lived here. The mansion was later donated to the San Diego Fine Arts Society, and during World War II the San Diego Museum of Art relocated there because troops took over Balboa Park for military training. (Courtesy of the San Diego History Center.)

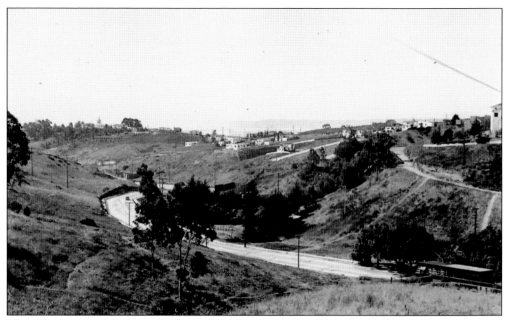

This photograph with a view facing south and looking west shows Reynard Way. There were two brickyards along Reynard Way. The Rankin Brickyard was established in 1887 at State Street, and Hubbard's Brickyard was established in the 1880s. As the area developed, it became an enclave for Portuguese and Italian fishermen. Longtime residents recall the sounds of fisherman singing when working their nets as the sun was setting over the ridge.

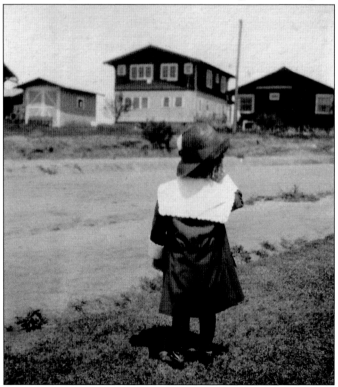

Pictured here in front of her Hermosa Way bungalow around 1913 is Mary Louise Stimson, facing the dirt road, two Craftsman homes, and a garage along Altamira Place. The majority of houses constructed in Mission Hills during the 1910s were bungalows and Craftsman-style homes. Altamira Place remains a short street with a high degree of intact homes, from bungalows to Spanish and Period Revival. (Courtesy of Erik Hanson.)

Two

MISSION HILLS
FROM ABOVE

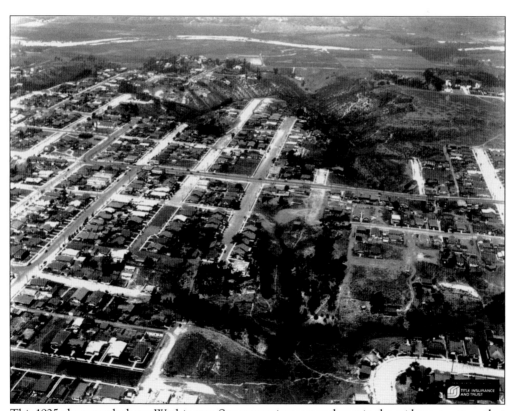

This 1925 photograph shows Washington Street running east and west in the grid street pattern that Nolan rejected in his proposed city plan. University Avenue does not yet connect to Washington Street. Mission Valley pastures and the San Diego River can be seen in the distance. Today, the area south of Washington Street is commonly referred to as South Mission Hills. (Courtesy of Michael Lynch.)

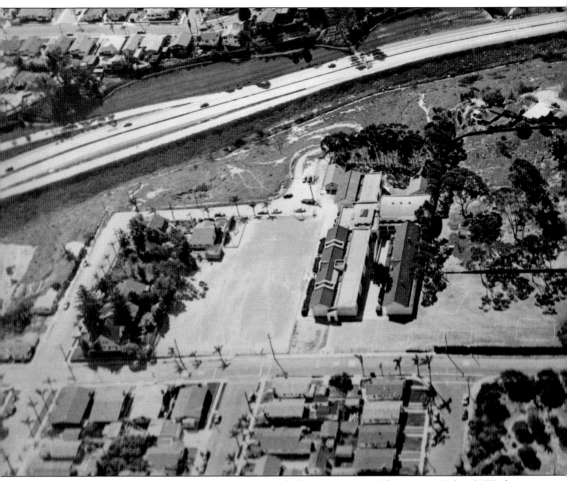

This May 1954 image captures the area around Ulysses S. Grant Elementary School, Washington Place, and the Calvary Cemetery (1875–1970) when it was still in use. The row of eucalyptus trees divided the cemetery into the Protestant (never used) and the Catholic sections before it was combined with the park. The Craftsman homes to the left of the school have been demolished for school expansion. The only original building on the school grounds (center) today is the 1910s bungalow at the upper right of the school. Most of the bungalows along Washington Place at the bottom of the photograph are intact. (Courtesy of Ulysses S. Grant Elementary School.)

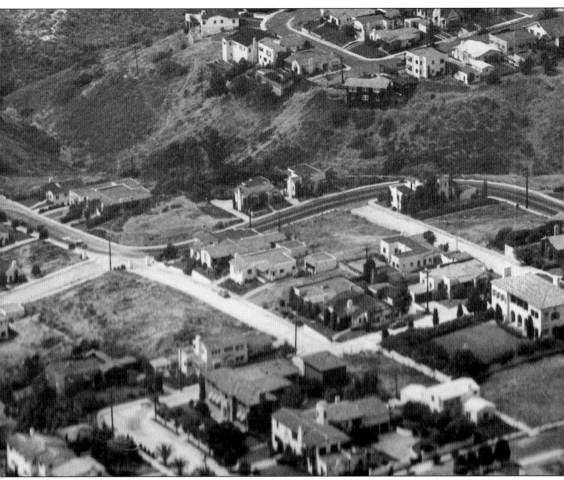

This late-1930s photograph depicts Sunset Road connecting to Juan Street toward Old Town. Traffic from La Callecita onto Sunset Road is diverted by two pillars with plaques. A pair of William Wheeler Sr. houses can be seen along Guy Street at the bottom of the image. In 1925, the corner house on Guy and Witherby Streets was built for Legler Benbough, and prominent attorney Michael Ibs Gonzalez later lived there. (Courtesy of Bruce and Alana Coons.)

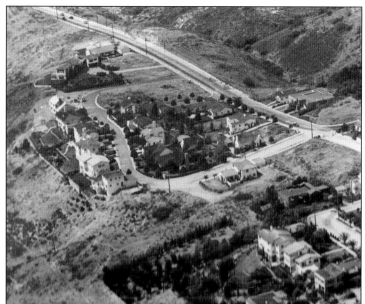

The 1930 Gordon L. Ely House in the upper left of the photograph, with the long driveway from Juan Street, is attributed to Richard Requa. Requa is credited with designing this grand Spanish Revival home for Ely during the grips of the Great Depression. Requa, like William Templeton Johnson and several other builders, worked and lived in Mission Hills. (Courtesy of Bruce and Alana Coons.)

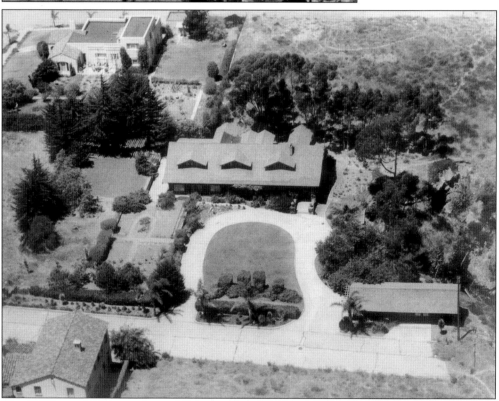

The 1912 James McMurtrie/James Witherow House, architect unknown, rests at the north end of Ampudia Street. It is an excellent example of a rustic Arts and Crafts design. The house has the appearance of a mountain lodge and was reportedly built on the site of the former 1890s Pastime Gun Club's lodge. The house at the bottom of the page is the 1926 Spanish Revival Johnson/Trepte residence. (Courtesy of Bruce and Alana Coons.)

This late-1930s photograph features the 1916 Prairie School Albert and Jesse Frost House on Altamira Place. In 1897, Frost commissioned William Hebbard and Irving Gill to design his residence on Broadway, and in 1911, he founded Frost Hardware Lumber. At far left is another Prairie School house, by Alexander Schreiber, the boyhood home to Modernist architect John August Reed. (Courtesy of Bruce and Alana Coons.)

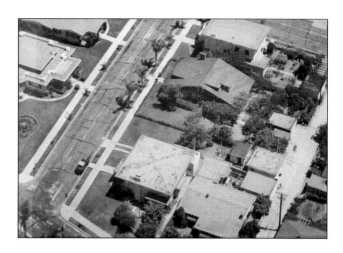

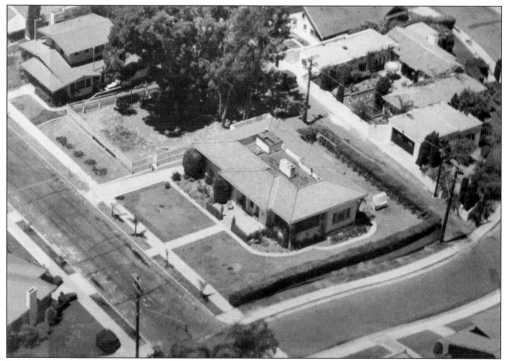

In 1913–1914, Harry L. Turner (born 1870) designed this Prairie School house for his family in the Allen Terrace subdivision at 1808 Altamira Place. The Turner house features leaded glass, large overhanging eaves with a hipped roof, and red tiles. Behind it is a U-shaped Richard Requa house. Notice the fenced-in vacant lot with mature trees next door; this was later the site of a William B. Melhorn house. (Courtesy of Bruce and Alana Coons.)

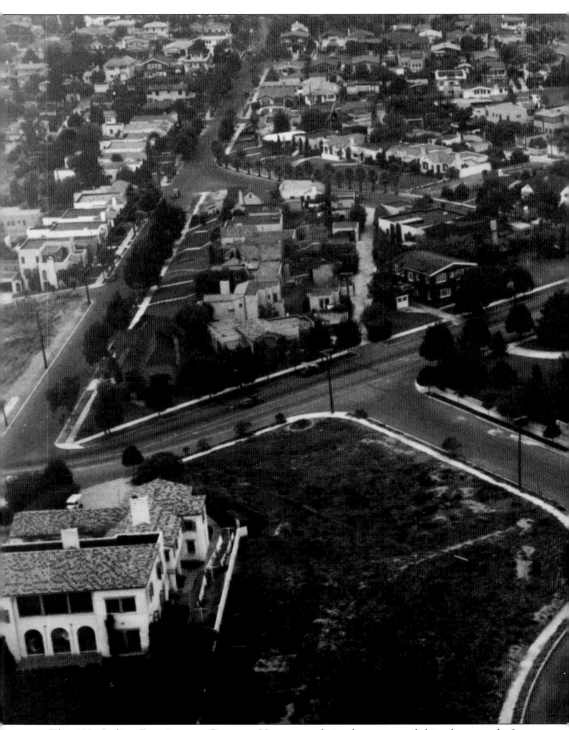

The 1921 Italian Renaissance Guymon House stands in the center of this photograph. It was designed by Los Angeles architect Robert Raymond. Tennis courts are across Orizaba Street. To the left on the same side of Sunset Boulevard is the 1920s Bertha Mitchell Spanish Revival mansion by the Los Angeles firm of John and Donald B. Parkinson. That firm is known for designing Los

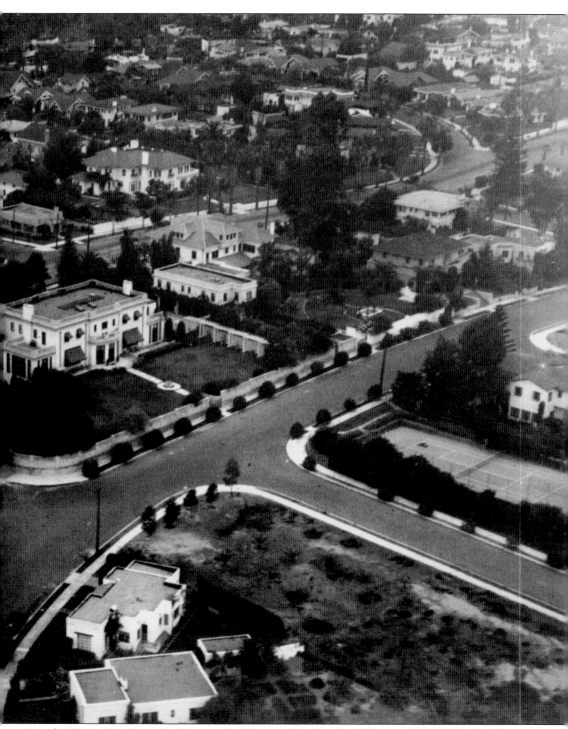

Angeles Union Station and other civic buildings in Los Angeles. The remodeled Villa Orizaba is to the right of the Guymon House. The western end of Sunset Boulevard featured Craftsman and Spanish Revival houses. The 1912 Milo C. Treat Mansion is seen just across Sunset Boulevard from Guymon's house. (Courtesy of Janed Guymon Casady.)

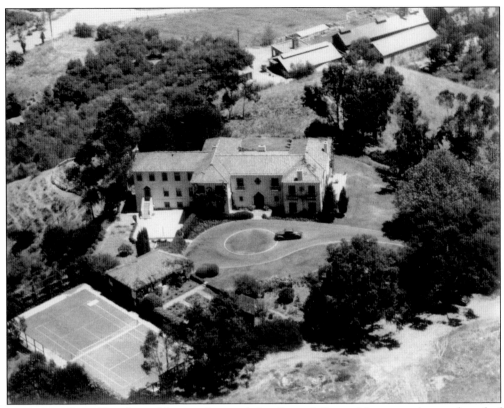

In 1918, William Templeton Johnson designed this Spanish Revival house at the north end of Trias Street overlooking Mission Valley for his family. Johnson studied at the École nationale supérieure des Beaux-Arts in Paris, and Bertram Goodhue invited him to San Diego, where he designed Spanish Revival houses, the Francis W. Parker School, and the Serra Museum. Later, Ewart Goodwin, the son of early Mission Hills cofounder Percy Goodwin, lived here. (Courtesy of Bruce and Alana Coons.)

Pine Street is the center street with Fort Stockton Drive at the top of the photograph. The 1926 Henry F. and Marion A. Lippitt house at 4481 Hortensia Street along the curve is a large Spanish Revival designed by William Templeton Johnson. Houses in this immediate area include work by Mead and Requa, Quayle Brothers, and Nathan Rigdon. (Courtesy of Bruce and Alana Coons.)

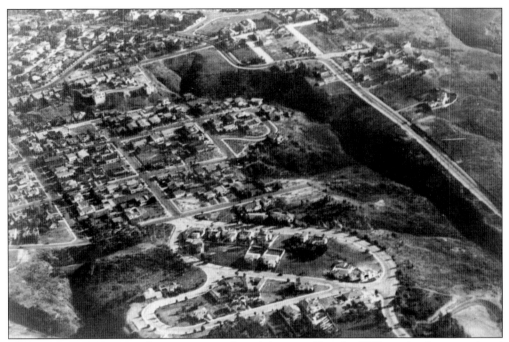

This 1933 aerial photograph incorporates the subdivisions Presidio Hills in the foreground and Mission Hills in the center and distance. By the 1930s, there were few available lots in the area. The 1933 Sheldon Hodge House by Cliff May at 4365 Altamirano Way, located in the lower section of this photograph, was an important design in May's career. It was a U-shaped hacienda that was lost in a 1970s gas explosion. (Courtesy of Mark Jackson.)

This late-1930s photograph shows George Marston's 1923 subdivision Presidio Ridge in the foreground and the 1926 Presidio Hills at the top. Like Mission Hills, it was designed using the principles of the Nolan Plan. Between 1927 and 1940, prominent San Diegans called upon architects and builders such as Cliff May, Alexander Schreiber, and Louis Preibisius to design houses in the Spanish Revival style, influenced by the 1929 Serra Museum. (Courtesy of Bruce and Alana Coons.)

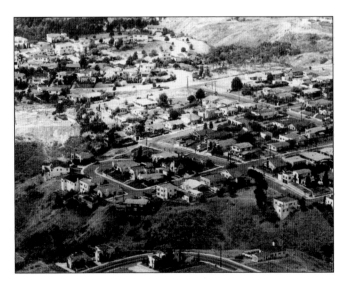

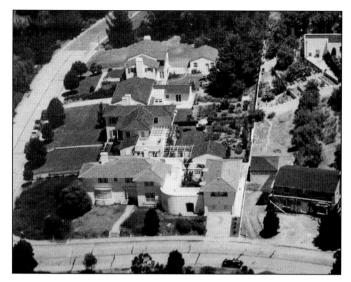

Built in 1938, the Irvine M. and Flora Schulman House on Presidio Drive and Cosoy Way is shown at the bottom of this photograph. Schulman left his bank position to begin a successful home furnishings business. Schulman was also an influential and important leader in the Jewish community and in philanthropic circles. Louis Preibisius designed this Art Moderne–style house across the street from Presidio Park. (Courtesy of Bruce and Alana Coons.)

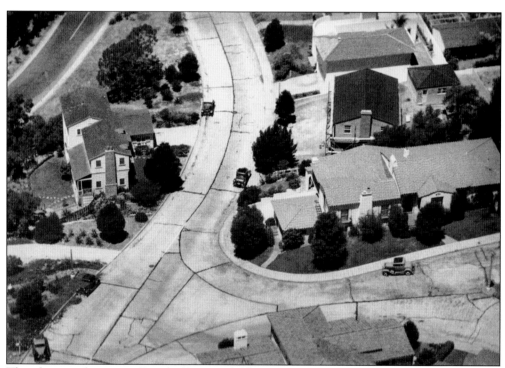

This photograph captures Presidio Drive and Altamirano Way in the late 1930s. Master architect Edward H. Depew designed the Jack Nuttall House, at left. Nuttall was a Commodore at the San Diego Yacht Club and founder of the Nuttall Marine Supply & Salvage Company. In 1929, he died accidentally in a boating accident. The Paul Brust House is on the right; Brust was a police surgeon for San Diego. (Courtesy of Bruce and Alana Coons.)

Three

THE SCHOOLS

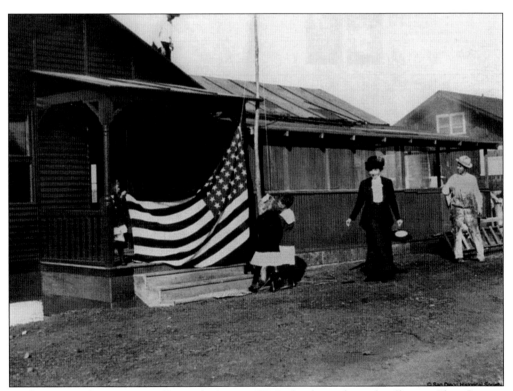

Students raise the American flag at the Francis W. Parker bungalow schoolhouse. Clara Sturges Johnson and William Templeton Johnson's niece attended the Francis W. Parker School in Chicago. The Johnsons were interested in modern movements for civic betterment as they had been active in civic affairs in Chicago and the East. The Johnsons founded the school because they wanted a progressive education for their children. (Courtesy of the Francis W. Parker School.)

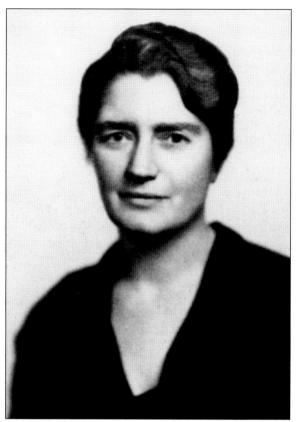

Pictured here is Clara Sturges Johnson, cofounder of the Francis W. Parker School. In 1905, Clara Sturges married William Templeton Johnson and encouraged his education and training at the Sorbonne in Paris. The Johnsons visited San Diego after France; this trip convinced the couple to settle here. The Johnsons built their first home in Coronado, and later lived in several locations in Mission Hills. (Courtesy of the Francis W. Parker School.)

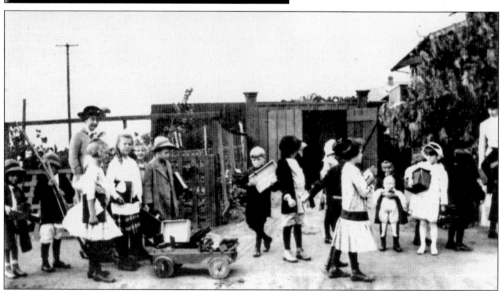

This 1913 photograph shows moving day from the redwood board-and-batten temporary bungalow school to the new Mission Revival school on Randolph Street, which opened December 31, 1912. The children carried many of the smaller school items, using little red wagons, while a moving van carried the larger school equipment. Faye Henley was responsible for the kindergarten and primary-age students. (Courtesy of the Francis W. Parker School.)

This is a 1913 photograph of the south wing and first portion of the Mission Revival Francis W. Parker School designed by William Templeton Johnson. The 1909 John H. Ferry Craftsman house behind the school is one of the oldest homes in Mission Hills. (Courtesy of the Francis W. Parker School.)

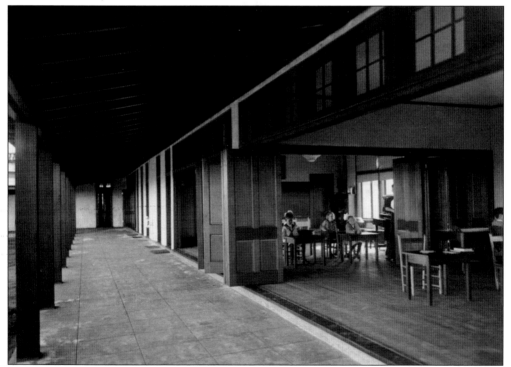

An open classroom in the south wing of the Francis W. Parker School is pictured here in 1914. William Templeton Johnson's plan called for a quadrangle with all classrooms opening onto an open courtyard with sliding doors. This is a key design element of the school. Progressive schools advocated by Col. Parker, John Dewey, Friedrich Frobel, and others rejected rote memory, emphasizing learning by doing and student-centered classroom content. (Courtesy of the Francis W. Parker School.)

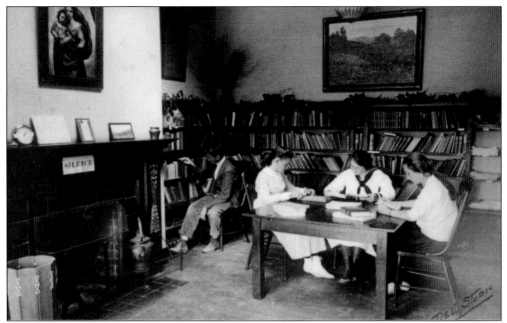

Francis W. Parker School's library, as shown here, was located in the school's south wing and featured Arts and Crafts movement designs, including a fireplace, plein air paintings, and furniture as well as an extensive collection of books. The Johnsons believed in the subconscious influence of artwork and surrounded students with photographs and prints of famous paintings. (Courtesy of the Francis W. Parker School.)

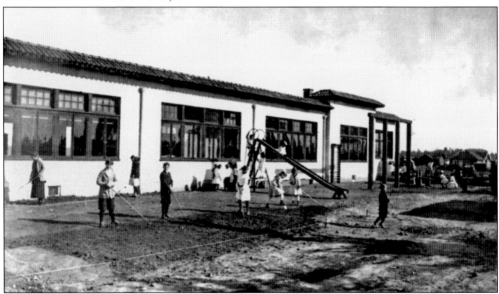

Children play in the school garden at the new Francis W. Parker School on Randolph Street. Designed in the Mission Revival style with red tiles, it was among the first schools in California to feature open-air classrooms. The school emphasized the importance of the great outdoors. Physical education was a fundamental part of an education based on Colonel Parker's principles. As the school grew, so did its collection of playground equipment. (Courtesy of the Francis W. Parker School.)

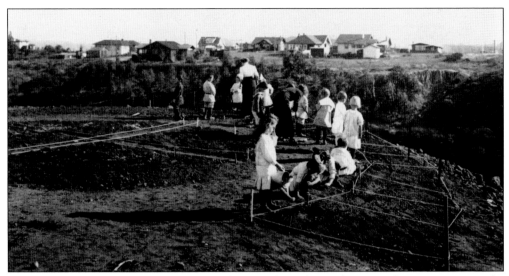

Francis W. Parker School horticulture students work in the garden around 1913, improving the school's landscaping. Directly east are bungalows and Craftsman-style houses on Jackdaw Street. At the 1913 dedication exercises, San Diego mayor Charles F. O'Neall and San Diego State Normal School president Edward Hardy spoke. By the end of its first year, the Parker School had grown to 60 students. (Courtesy of the Francis W. Parker School.)

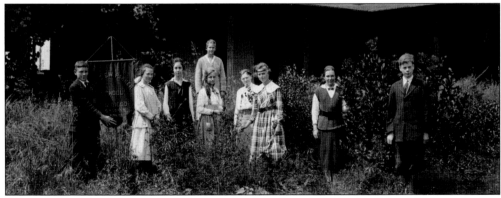

This is a May 10, 1918, courtyard photograph of the Francis W. Parker School 10th-grade class. As a progressive school, Francis W. Parker provided students with practical experiences, including planning and budgeting in the cafeteria, raising flowers and vegetables for the school, and at one point even attempting to raise bees and sell honey. (Courtesy of the Francis W. Parker School.)

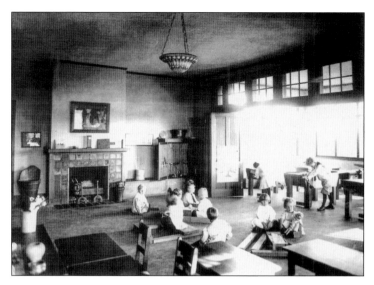

Kindergarten students learn about manual labor in 1918. The curriculum included woodworking, basketry, and weaving. Take notice of the Arts and Crafts–style furniture and fireplace, aside from the students' construction projects. Also, notice the light fixture, paintings, and large windows for ample natural light. (Courtesy of the Francis W. Parker School.)

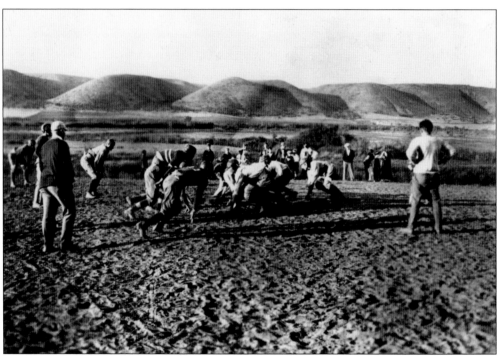

In 1918, a Francis W. Parker School Athletic Association was formed. Team sports included football and basketball for boys and volleyball and basketball for girls. Football games were held on a dusty field in Mission Valley near the modern-day site of a hotel. When the team scored a touchdown, someone would ring one of the mission bells along El Camino Real. (Courtesy of the Francis W. Parker School.)

In 1919, the Francis W. Parker School auditorium was under construction. The new auditorium dwarfed a nearby tent that had formerly served as the school cafeteria. In March 1919, the school's 100th student, Herbert Flint, was given a bouquet of 100 yellow violets to celebrate the milestone. (Courtesy of the Francis W. Parker School.)

The new Francis W. Parker School auditorium with faculty and students is shown photographed about 1920. In 1922, Ethel "Happy" Sturges Dummer was appointed principal and continued the influence of the Sturges family on the school. Happy's younger sister Francis taught arts, crafts, and folk dancing. Mrs. Dummer would serve as principal until 1929, and was later active as a director until her death in 1938. (Courtesy of the Francis W. Parker School.)

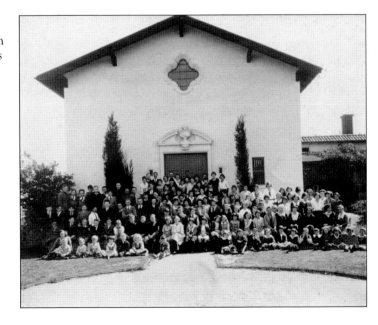

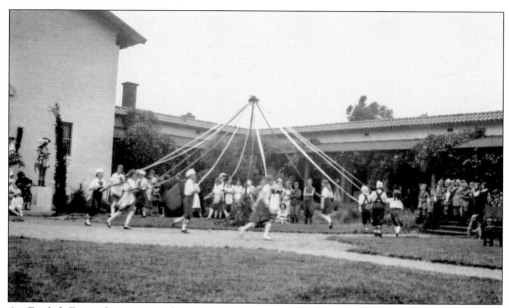

An English Festival one spring during the early years of the Francis W. Parker School included a maypole dance, beginning a tradition that carries on today. Students dance on May Day in front of the school's auditorium. Plays, assemblies, and festivals were central to the education program during the early years. (Courtesy of the Francis W. Parker School.)

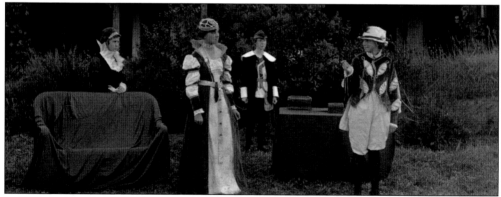

In 1919, the Francis W. Parker School put on a production of Shakespeare's *The Merchant of Venice*. Dramatics at the school were collaborations between the English, Drama, and Arts Departments. The Arts and Manual Training Departments created scenery and costumes, sometimes with parental assistance. The Thespian Society was popular with students. (Courtesy of the Francis W. Parker School.)

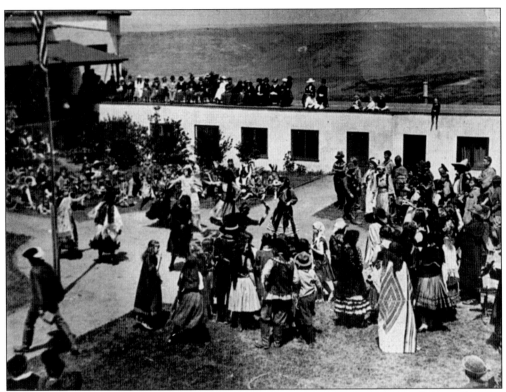

During the spring of 1920, spectators watched from the portico and the roof along the new north wing of Francis W. Parker School during a Spanish Pageant, Fiesta, and Fair that filled the courtyard with scenes of mission life and dancing. Mission Valley is situated to the north, and Parker students made field trips to the site of ruins at the nearby Presidio and to the Mission San Diego de Alcalá. (Courtesy of the Francis W. Parker School.)

Students study on the portico around 1920, taking full advantage of San Diego's mild climate, which is ideal for an open-air school. William Templeton Johnson set out to construct a practical and efficient building at a low cost and achieve an artistic effect by good proportions and pleasing color, rather than by use of lavish and expensive ornament. (Courtesy of the Francis W. Parker School.)

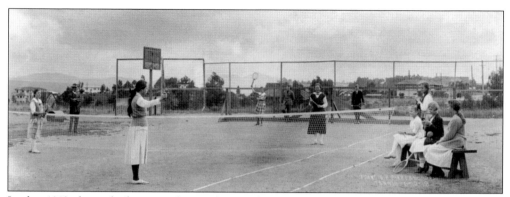

In this 1918 physical education class, girls are taking tennis lessons. Court rules stipulated "If a person loses his self-control in tennis by bursting out with a slang word or by demonstrating his or her feeling to watchers by throwing their racquet, they are condemned to withdraw from the field for that period." Avalon Drive is to the left and Jackdaw Street, in the background. (Courtesy of the Francis W. Parker School.)

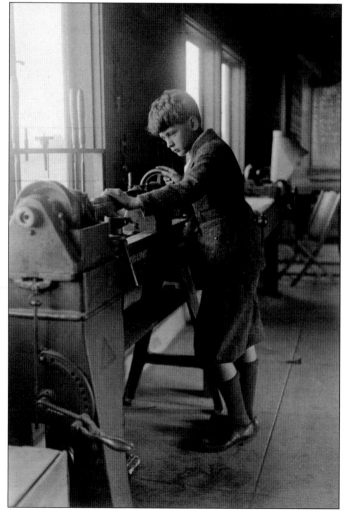

Manual training classes at Francis W. Parker School had the upper school boys making equipment for the lower grades, as demonstrated in this 1920s shop class photograph. Students had the privilege of working on projects to satisfy an interest in a subject. Students enjoyed music, dance, and physical education as well as field trips to factories, flour and sawmills, and Wangenheim's wholesale grocers. (Courtesy of the Francis W. Parker School.)

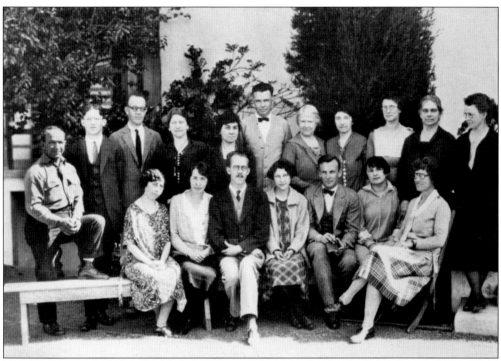

Pictured here in 1926 is the faculty of the Francis W. Parker School with principal Ethel "Happy" Sturges Dummer (first row, left). Abdullah Ben Tahar Sid Mohammad, known as A.B. or Mr. Tahar (second row, far left with his foot on the bench), taught physical education. He was the son of an Arabian sheik and had been an acrobat and circus performer. (Courtesy of the Francis W. Parker School.)

Students contributed to the war effort by filling sandbags along Randolph Street during World War II. Visible behind the basketball court along Randolph Street and Arbor Drive are Tudor Revival and Spanish Revival houses, including an Edward Depew house on the corner. (Courtesy of the Francis W. Parker School.)

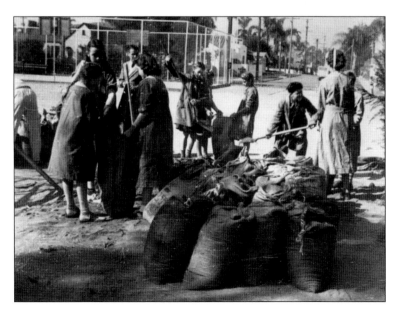

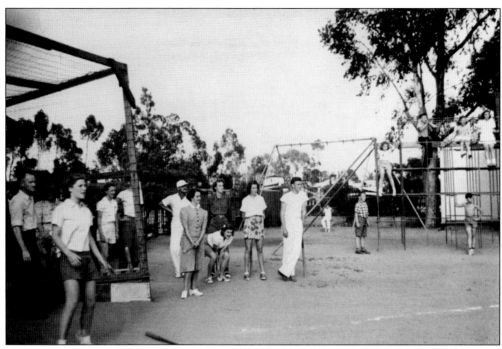

One of the teachers is at bat during physical education class in this 1940s photograph. By then, most of Mission Hills was fully developed. The monkey bars and swing sets were standard issue for most playgrounds of the era. (Courtesy of the Francis W. Parker School.)

The original Ulysses S. Grant Elementary School opened in 1914 and was named after former president and Civil War general Ulysses S. Grant. In the 1890s, two of the president's sons, Ulysses S. Grant Jr. and Jesse Grant, came to San Diego and would play important civic and business roles here. (Courtesy of Sharon Hicks Anderson.)

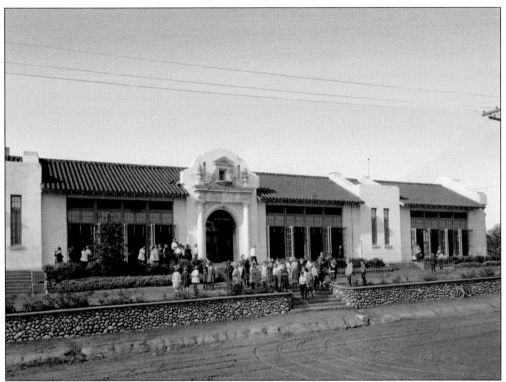

Pictured here around 1925 is the front of the Mission Revival Ulysses S. Grant Elementary School. The school had 16 classrooms, an auditorium, and a basement with a cafeteria, library, and a bicycle room. The school featured operable French doors and impressive decorative detailing around the main entry that would be removed after World War II. (Courtesy of the San Diego History Center.)

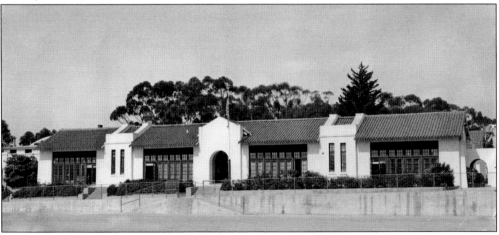

This May 1954 photograph captures Ulysses S. Grant Elementary School more than 20 years later. In 1914, Theodore C. Kistner Sr. (1874–1973) likely designed the beautiful Mission Revival school. Kistner designed two San Diego County Carnegie libraries as well as San Diego schools, including Roosevelt Junior High (1921). Reportedly, there were no windows facing the adjacent Calvary Cemetery so students would be less distracted during burials. The eucalyptus treetops in this photograph are in the cemetery. (Courtesy of Ulysses S. Grant Elementary School.)

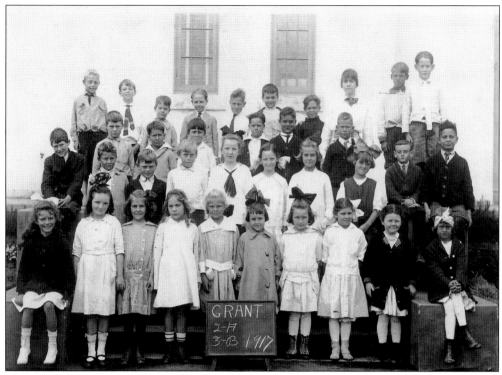

In 1933, the California Field Act required that schools meet earthquake safety standards. The school survived until 1973, just after the 1971 San Fernando earthquake, but the decision was made to tear down the beautiful old school. A number of older San Diego schools suffered a similar fate during this time. This is a photograph of the Ulysses S. Grant Elementary school second and third grade class in 1917. (Courtesy of Ulysses S. Grant Elementary School.)

Virginia and George Baker pause for a moment on the playground at Ulysses S. Grant Elementary School in 1947. The Baker family lived nearby on Washington Place, and the children went to church locally, joined the Boy and Girl Scouts, went to Roosevelt Junior High, and graduated from San Diego High School. (Courtesy of Bette Baker Bouchér.)

The Ulysses S. Grant Elementary School eighth grade class of 1919 and teachers are pictured here. The photograph includes, from left to right, (first row) Francis Richards, Elizabeth Thomas, Blodwen Williams, Vera Maddison, Florence Ena, Louise Driver, Louisa Kliensmid, Harriet Pollack, and Iva ?hapin; (second row) Eleanor Johnston (teacher), Donald Mapson, Mary Salyers, Virginia McAuliff, Mary Beaton, Adelaide Shepley, Agnes Wood, Eugenia Hawworth, Christine Squires, Margaret Beard, and Lewis Oberkotter (teacher); (third row) Harvey Goodman, Jack Kelly, John Grinstead, Anthony Moran, Alan McGrew, Whitney Rannells, Howard Williams, Norton Langford, Goodwin Quinn, Edward Fegan, Lewis Shellback, and Reed Whaley. (Courtesy of Ulysses S. Grant Elementary School.)

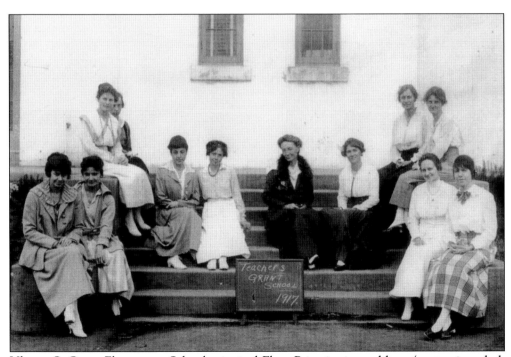

Ulysses S. Grant Elementary School principal Flora Price is pictured here (center, in a dark coat) with her faculty. Price lived nearby at 3750 Pioneer Place. (Courtesy of Ulysses S. Grant Elementary School.)

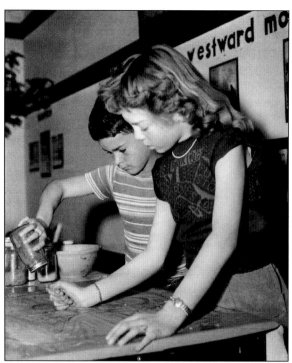

In this 1950s photograph, Sharon Hicks Anderson and Richard Crittenden work on a finger painting in art class. Sharon was born in nearby Mercy Hospital and grew up at 4016 Lark Street in a bungalow a few houses down from the Methodist church. When she was little, she practiced her math skills by subtracting birth dates from death dates at the Calvary Cemetery next door. (Courtesy of Sharon Hicks Anderson.)

In 1916, the Marston Store started a library. In 1921, the books transferred to Ulysses S. Grant Elementary School. In 1950, the library moved to the northeast corner of Goldfinch and Washington Street, and in 1961, to West Washington Street. This photograph shows some of the 1950 sixth-grade graduating class at Ulysses S. Grant Elementary School: from left to right, Louis Celicio, unidentified, Billy O'Donovan, Manuel Bernardi, and unidentified. (Courtesy of Sharon Hicks Anderson.)

Four

THE CHURCHES
AND A CEMETERY

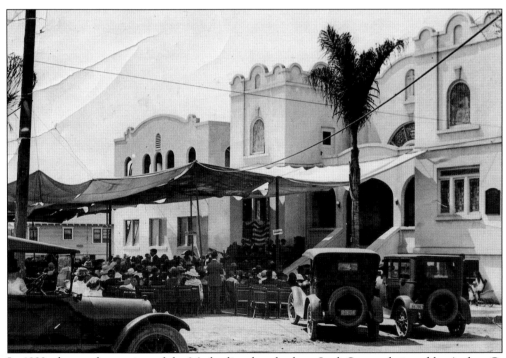

In 1922, the southern wing of the Methodist church along Lark Street, designed by Arthur G. Lindley, was dedicated. Rev. John E. Beery, originally from Ohio, came to San Diego for his health, first serving as the minster at National City's Methodist church before coming to the Mission Hills Methodist Church in 1915. (Courtesy of MHMC.)

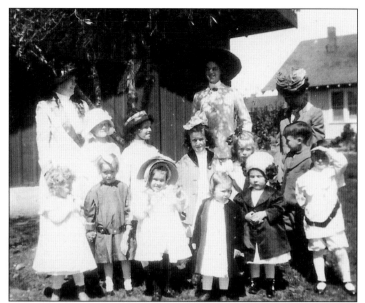

On January 29, 1911, the Mission Hills Congregational Church began at a bungalow on the northeast corner of Hawk Street and Getti Street (now Fort Stockton Drive). The 28 members sat on planks and boxes but were inspired by Rev. Willard B. Thorp and Rev. D.F. Watkins. That summer, a redwood board-and-batten church was constructed by master architect Emmor Brooke Weaver at Jackdaw and Getti Streets. (Courtesy of the UCC.)

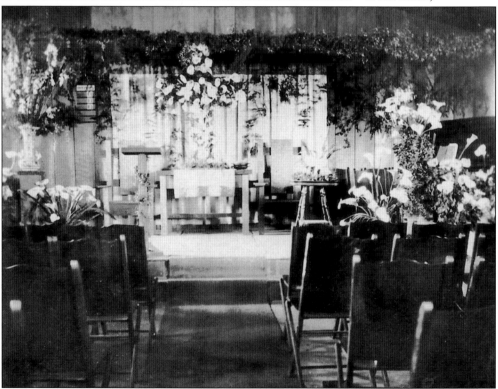

This is an interior photograph of the Mission Hills Congregational Church. The redwood board-and-batten bungalow was dedicated on July 2, 1911. Emmor Brooke Weaver used rough 12-inch boards outside that were beautifully finished on the interior for a total cost of $3,000 for the church. The first minister of the Congregational church was Rev. John Doane from Greely, Colorado. The Doanes also had Weaver build a redwood bungalow for their family on Lyndon Road. (Courtesy of the UCC.)

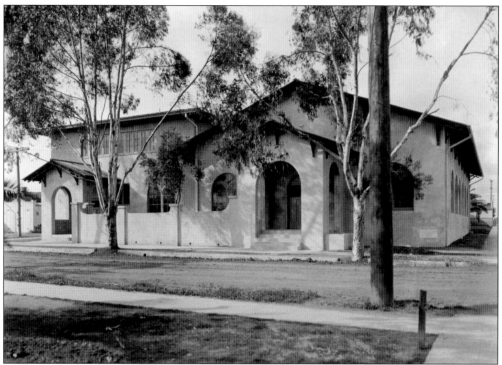

By 1915, the Mission Hills Congregational Church was outgrowing its rustic bungalow. Louis Gill was selected to build a new, larger church. Many members were loath to give up their bungalow chapel, as they did not wish to lose the spirit of the place. Gill designed a church with reminders for its members of their beloved first church. In 1921, the new church was completed at a cost of $27,500. (Courtesy of the UCC.)

This is a construction photograph from the late 1940s. The Mission Hills Congregational Church added a new education and recreational building at a cost of $100,000. Rev. Lawrence A. Wilson planned the large addition, and Rev. John C. Wiley was the church pastor at the time of the dedication. (Courtesy of the UCC.)

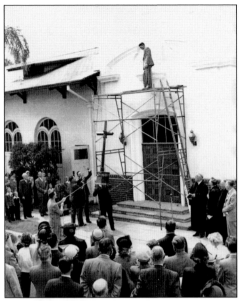

A March 1950 photograph shows the cross being hoisted for placement in the niche on the chapel. Dignitaries are standing by the ladder; from left to right are Rev. John C. Wiley, Dr. Willis L. Goldsmith (former minister), Rev. Lawrence A. Wilson (former minister), and Rev. E. B. Adams from the Congregational Church Conference of California and the Southwest. (Courtesy of the UCC.)

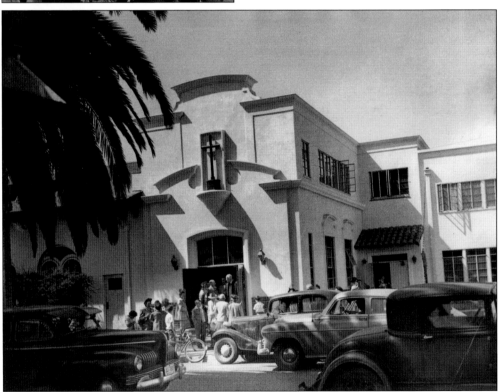

Rev John C. Wiley is shown at the door in March 1950, welcoming parishioners to the Congregational church's dedication celebration and to the new side entrance on Jackdaw Street. The building includes Mission Revival features such as the parapet, Spanish Revival–style door, and tile shed roof over the side entrance complementing the 1921 Louis Gill design. Rev. Wiley and his family lived in a 1920 California Craftsman bungalow at 1824 Sunset Boulevard before moving to Japan in 1953. (Courtesy of the UCC.)

These 1950s photographs of the Mission Hills Congregational Church during Easter Sunday services show attendees gathering before services (above) and then seated as members of the children's choir enter the church singing from their hymnals (below). Many well-known residents attended this church, including the Agnews, the Greens, Wesley Hale, the Hepners, the Kellys, the Nuttalls, the Rigdons, the Requas, the Samples, Hannah Schreiber, and the Treptes, in addition to many more Mission Hills families and residents. The original Emmor Brooke Weaver chapel ran the length of Fort Stockton Drive, but Louis Gill laid the new church out lengthwise along Jackdaw Street instead. (Both, courtesy of the UCC.)

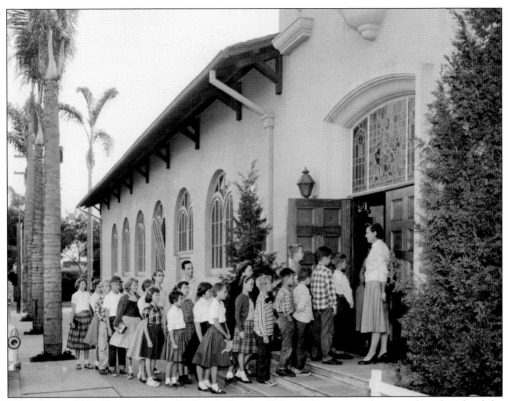

The Mission Hills Congregational Church Sunday School class enters the new chapel with adults Jean Sheppard and Mrs. Bruce Talbert about 1958. Earlier in his career, Louis Gill, architect of the addition, worked with his uncle Irving Gill, Frank Mead, and Richard Requa. It appears that Gill may have borrowed design details from these celebrated architects such as the stacked, recessed eaves. Stacked eaves are rarely seen as a design element in Mission Hills buildings. (Courtesy of the UCC.)

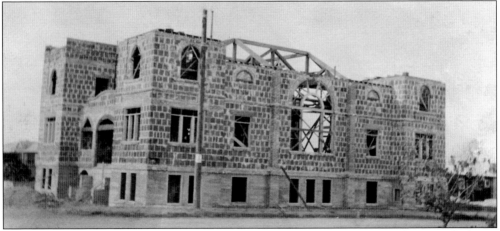

In 1913 and 1914, the Board of Trustees for the Mission Hills Methodist Church met at the home of Frank and Mary Byrkit at 1811 Sheridan Avenue. In 1913, four lots were purchased at the corner of Getti (now Fort Stockton Drive) and Hooker (now Lark Street) for the church. Pictured here is the hollow clay tile construction before it was covered with stucco. (Courtesy of MHMC.)

An early minister at the Methodist church was the Reverend Earl Henry Haydock. He was born in Kansas (1886–1970) and later married Marguerite Roberta Keister Haydock (1884–1970). Haydock was minister from 1918 to 1923 and was largely responsible for the oversight of the southern addition to the Methodist church in 1922. (Courtesy of MHMC.)

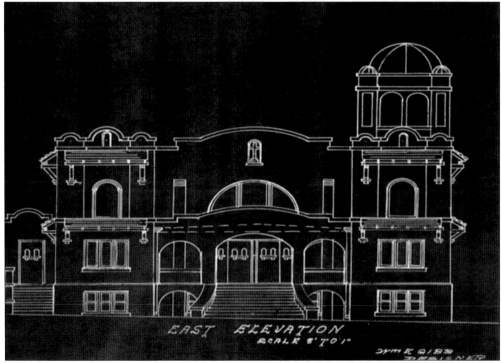

This blueprint shows the never-built bell tower and the first- and second-floor tile overhangs for the windows designed by William E. Gibb. The church was dedicated on January 17, 1915. Frank Byrkit, president of the church trustees, retired to Mission Hills from Iowa. He attended Wesleyan University, served in the Iowa infantry during the Civil War, and was president of the First National Bank in Iowa. He died in 1916, just after the church was built. (Courtesy of MHMC.)

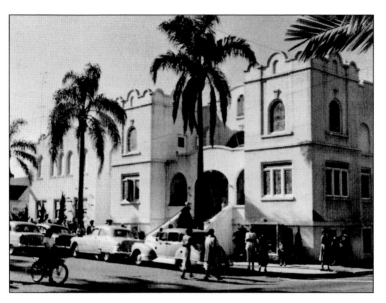

This is an early-1950s photograph of the Methodist church. When the building was constructed, the church paid $750 for the art glass windows by the Los Angeles firm Judson Studios. Judson Studios was a member of the Arroyo Guild and a leader during the early 20th-century Arts and Crafts movement in Southern California. (Courtesy of MHMC.)

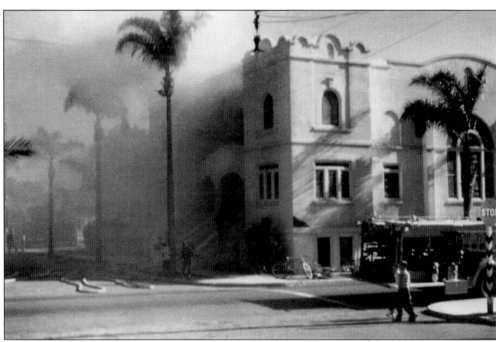

On June 15, 1951, firefighters responded to a large fire at the Methodist church. Early church members were key to assisting on the building materials and furnishings for the 1915 Methodist church, including Forrest Hiaett, who supplied the hollow clay tiles. The chairs came from Benbough Furniture, and the organ was from Thearles Music Store. Interior features include Arts and Crafts woodwork. (Courtesy of MHMC.)

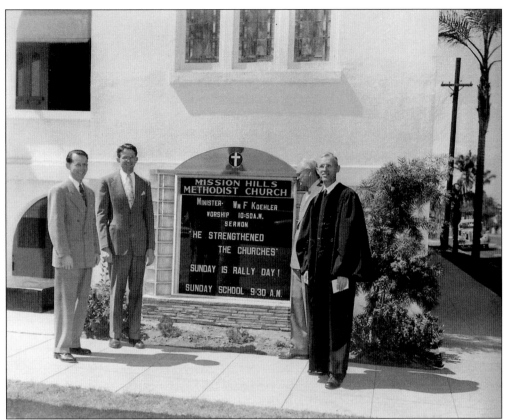

Pictured here is the 1948 glass block marquee when it was dedicated at the Methodist church. Present at the ceremony are, from left to right, Em Owens, Bob Bohler, Charles Lutes, and Rev. Koehler. Some of the church members of this time included the Prestons, the Taylors, the Staffords, the Cranstons, the Pharises, Mrs. Caldwell, Mrs. Thompson, Miss Schuyler, Eula Harris, Jean Windell, Skip Hemphill, the Bakers, the Brownlees and minister Eugene Woods. (Courtesy of MHMC.)

The Methodist Youth Fellowship stands in a circle in front of the church in the 1950s. The young adults' group was called the Contempos, and it held progressive dinner parties and picnics. (Courtesy of Bette Baker Bouchér.)

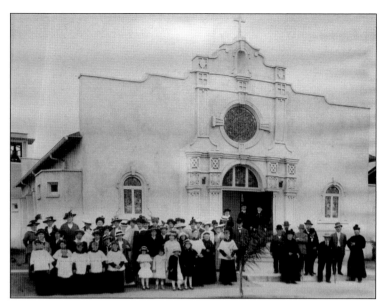

In 1910, Thomas Conaty of Monterey-Los Angeles purchased three bungalows on Hawk Street and started St. Vincent de Paul Catholic Church. The church celebrated its first mass on April 26, 1910. This Mission Revival church was built in 1918 with dark, wood interiors, stained glass, and a freestanding wooden bell tower. (Courtesy of Jasmine Jones.)

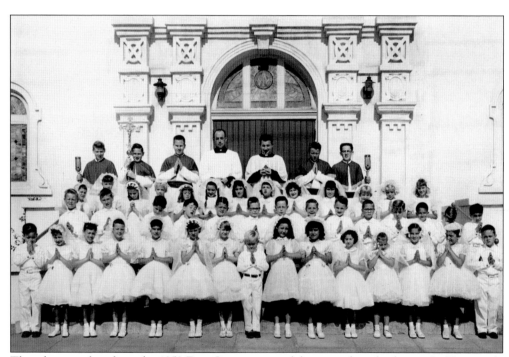

This photograph is from the 1959 First Communion of the second-grade class at St. Vincent de Paul Catholic Church. Identified are Maria Vattuone Ciceric (first row, fourth from the left) and Marjorie Marks (first row fifth from the left). In 1968, the Mission Revival church was demolished to make way for a more modern design. In 2010, the church and school were updated again. (Courtesy of Marjorie Marks.)

An undated photograph of Calvary Cemetery caretaker Peter O'Malley and his wife appears here. O'Malley (born in Ireland in 1846) looked after the Catholic cemetery as a volunteer until his death in 1933. His home was at 1701 Washington Place. His daughter Bridget died at age 11 on the very day she was going to be baptized by their close friend, Fr. Antonio Ubach. (Courtesy Rose Beyerle.)

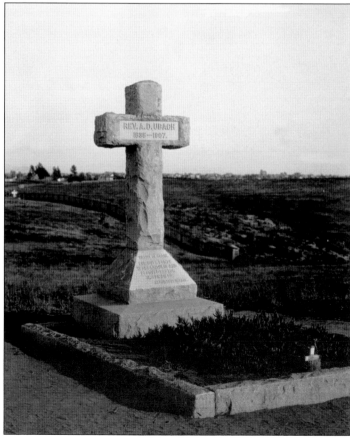

In 1866, Fr. Antonio Ubach (1835–1907), the "Last of the Padres," arrived in San Diego from Spain and was in charge of the Catholic parish until his death. He was the inspiration for Helen Hunt Jackson's character Father Gaspara in her book *Ramona*. Around 1875, Father Ubach laid out Calvary Cemetery. He cared deeply about Native American rights, began Old Town's Immaculate Conception Church, and now lies buried beneath a parking lot. (Courtesy of the San Diego History Center.)

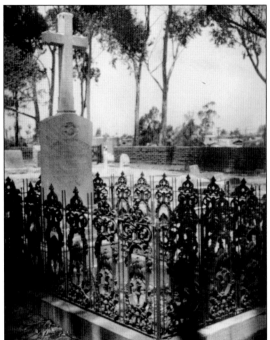

Cave Johnson Couts (1821–1874) was a graduate of West Point, where he was a classmate of future generals (and president) Ulysses S. Grant, William Tecumseh Sherman, and Robert E. Lee. In 1848, Couts arrived in San Diego with the Black Dragoons, married Ysidora Bandini, and lived at the Rancho Guajome. Couts served as the judge advocate at Antonio Garra's trial, and he was twice acquitted of murder himself, including the charge that in 1865 he killed Juan Mendoza in Old Town's Plaza. (Courtesy of the San Diego History Center.)

Pictured here are some of the 138 collected grave markers from the Calvary Cemetery (1875–1969), one of San Diego's oldest cemeteries. The appropriately 3,000–4,000 remains were not exhumed and are still buried there, including many Old Town pioneers. The Great Spanish Influenza of 1918–1919 was responsible for the most burials. In 1970, grave markers were removed from their positions and most were destroyed when the area was converted into Calvary Pioneer Memorial Park.

Five

FAMILY LIFE

Mary Louise Stimson (right) is seen with two unidentified friends and "Uncle Phil" in front of the Stimson family bungalow at 4355 Hermosa Way about 1915. The bungalow in the background is north of 4355 Hermosa Way. It features a stucco exterior with cobblestone rocks artistically placed on the chimney, which is a character-defining feature of the Arts and Crafts movement. The rocks were likely uncovered and utilized on-site. (Courtesy of Erik Hanson.)

Pictured here is the Barnett family with Alice Barnett Price Stevenson (center). Born in Illinois in 1886, she was a child prodigy and studied with composer Hugo Ludwig Kaun. Between 1906 and 1932 Stevenson composed 110 works. In 1926, she married Dr. George Roy Stevenson. In 1927, she founded the San Diego Symphony Orchestra at her home at 1816 Sheridan Avenue. She died at age 89 in 1975. (Courtesy of Eugene Price.)

In this 1940s photograph, Lillian and Leslie Gordon Norquist stand in front of their 1218 West Lewis Street house with their pet rabbit Buntsie. People would drive by on the weekends from all over to see their bunny in the front yard. The Norquists moved to San Diego in 1940 by driving Lillian's 1933 Ford Coupe from Minnesota following a Christmastime blizzard. (Courtesy of Anne Marie Boykin.)

The Norquist family pose in front of their bungalow at 1218 West Lewis Street. Leslie and Lillian's (second from right) sons Richard and Wayne crouch in front. While this bungalow still stands, the Craftsman home at the right was demolished sometime after this photograph was taken in the 1940s. West Lewis Street is mostly intact with the exception of a handful of small, 1950s apartment buildings. (Courtesy of Anne Marie Boykin.)

Jane Irons Guymon and her daughters Janed and Anne are seen at the backyard fountain of the Guymon house in this 1940s photograph. The house is a large, 1921 Italianate-style structure. Jane was born in San Pedro, married Rusty Irons, and later wed Edward "Ned" Guymon Jr. During World War II, she was a Red Cross volunteer at Balboa Naval Hospital. She also hosted pool parties for the Old Globe Theater cast members at the house. (Courtesy of Janed Guymon Casady.)

In 1958 Sarita Jo Mattson (first row left) celebrates her birthday with unidentified girlfriends, mostly from the San Diego High School, in front of her house at 3665 Jackdaw Street. The house was built in 1929 and is now historically designated. The English Cottage bungalow was a speculative house originally owned by Mary and Julia Pickett, two schoolteachers. Gunnar E. Johnson, a native of Sweden, built it just before the Great Depression. (Courtesy of Sarita Jo Mattson.)

Sophie Aronovsky Mattson and daughter Sarita Jo pose in front of their home at 3665 Jackdaw Street. Sophie was born in London, England, graduated from Radcliffe University, and taught French, Latin, German, and English classes at San Diego schools from the 1940s until 1960. To the left in the background is the board-and-batten garage of the Craftsman house located next door. (Courtesy of Sarita Jo Mattson.)

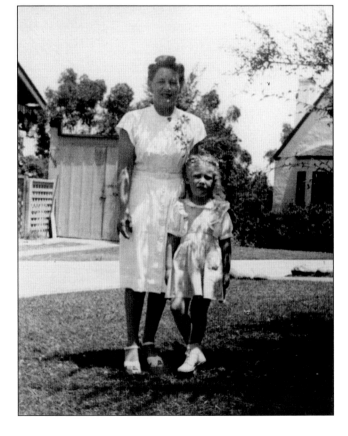

Pictured is the Miller family on Thanksgiving Day 1931: from left to right (first row) Morgan and Hester; (second row) Merrill T. Miller Sr., and Merrill Jr. Sarah Johnston Cox Miller (1844–1907) was Merrill T. Miller Sr.'s grandmother, and his father was Henry L. Miller (1863–1920). Sarah was the stepdaughter of Capt. Henry J. Johnston. Henry L. Miller subdivided and marketed Inspiration Heights. The Millers lived in a 1927 Richard Requa Spanish Revival house next door to the Villa Orizaba. (Courtesy of Irene and Merril Miller Jr.)

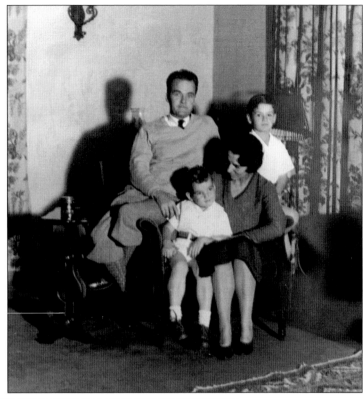

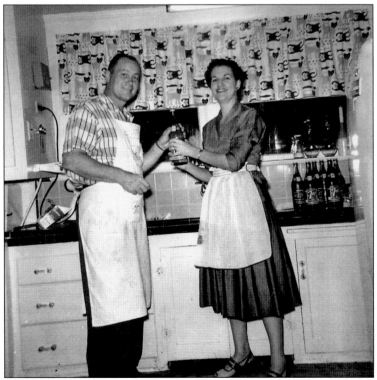

Howard and Lauretta Pharis are busy in their kitchen getting ready for a party at 1778 West Lewis Street. They were leaders in the Methodist church young adult's social group the Contempos. Their kitchen was a typical bungalow kitchen that had escaped postwar remodeling, at least up to the date of this photograph in 1956. (Courtesy of MHMC.)

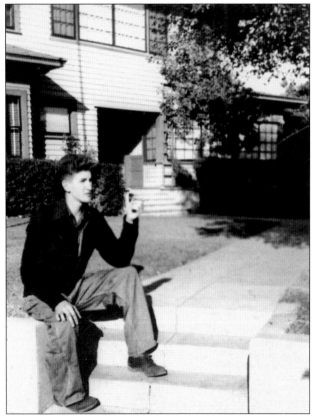

This 1930s photograph shows future Modernist architect John August Reed (second row, between his parents) as a 10-year-old boy with brothers Orrel Philip Jr. (first row, left) and David at their house on Altamira Place. The glass block room addition was completed around 1938. It is believed to be the first three-sided glass block room with a skylight in California. The Reed children went to Francis Parker School. (Courtesy of John Reed.)

An unidentified soldier rests in front of the Kelly Residence, 4229 Saint James Place, in 1942. This soldier took his meals at this Craftsman house during World War II. Many servicemen doubled up in Mission Hills homes during the war years, as there was a critical housing shortage in San Diego at that time. (Courtesy of Valerie Schwartz.)

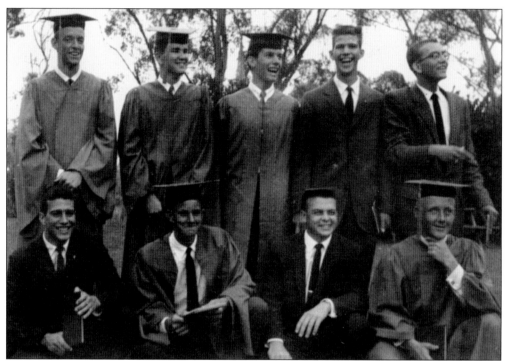

Most Mission Hills high school students attended nearby San Diego High School. These students who graduated in 1957 from San Diego High School are, from left to right, (first row) Hadley Batchelder (lawyer), Robert Frazee (paint company), Carl Hillenbren (lawyer), and George Baker; (second row) Don Hansen (lawyer), Mike Sinnot (college teacher), Norman Carnes Jr. (Navy officer), Steve Young (dentist), and Ted Cranston (lawyer). (Courtesy of Bette Baker Bouchér.)

The Baker family and friends chat in front of the Methodist church in the 1950s. From left to right are Ted Cranston, unidentified, Bette Baker, Linda Ware, Aunt Zetta Baker visiting from Ohio, and Virginia Baker. The row of 1910s and 1920s bungalows along Lark Street is mostly intact today. (Courtesy of Bette Baker Bouchér.)

Virginia Baker and her daughter Bette glance at each other in front of their 1844 Washington Place bungalow. They were on their way to the Methodist church. Some of these simple clapboard bungalows are still intact along Washington Place. (Courtesy of Bette Baker Bouchér.)

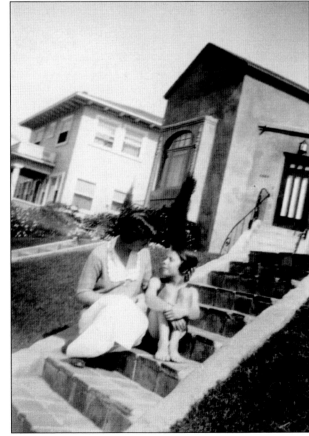

Dorothea Vinton and daughter Jane sit on the steps of 4460 Hermosa Way in 1926. The house was built in 1924 by John Dudley Phelps and is now historically designated. The first owners were William and Vera Wylie, and the Vintons lived next door at 4470 Hermosa Way. (Courtesy of Cindy Williams.)

Bette Baker prepares for her wedding in 1960 at the home of the Methodist church's minister. He lived across the street in a bungalow at the corner of Fort Stockton Drive and Lark Street, in a single-story bungalow with a typical Craftsman interior, built-in bookcase, and Arts and Crafts tile fireplace. The wedding party includes, from left to right, Leola Conner, Jeanne Stewart, Dhynna Latta, Baker (bride), and Anne Schrake. (Courtesy of Bette Baker Bouchér.)

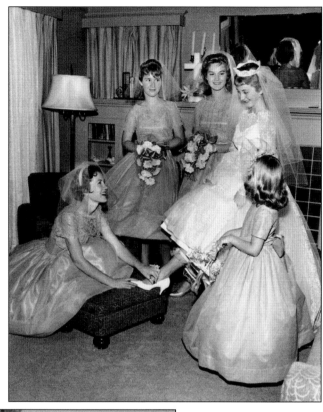

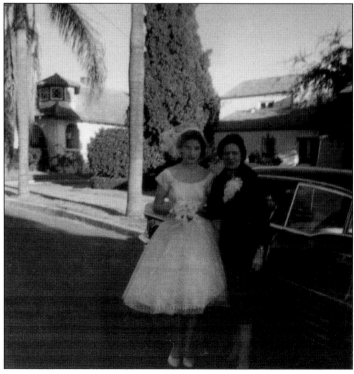

Cynthia Graham poses on her wedding day with Nancy Leavenworth along Sheridan Avenue. Cynthia married Henri Charmasson on December 30, 1960. The reception was held at the Leavenworth residence, an Emmor Brooke Weaver Craftsman on Sheridan Avenue. The house on the left is the Mission Revival–style 1913 Guy and Gladys Vinton house. The house on the right is a 1924 Spanish Revival home built by George Daley. (Courtesy of Mari Charmasson.)

This is a 1950s photograph of Elizabeth M. Miller at the 1936 Lorraine and Harold Tucker residence, designed by Cliff May. Along with her husband, Willis H. Miller, PhD, she lived here from 1949 through the mid-1960s. He was the first San Diego County planning director. Note the original terra-cotta roof tiles laid in an irregular fashion, a key Cliff May design feature. (Courtesy of Mark Jackson.)

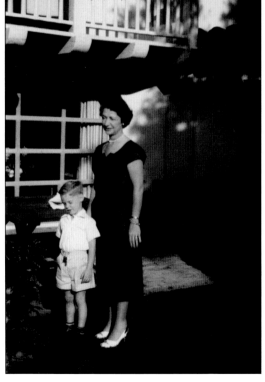

This is a 1950s photograph of Elizabeth Miller with her nephew Mark Jackson in the courtyard of her Cliff May home in Presidio Hills. The second-story balcony is a design feature of the Monterey style, which Cliff May rarely used. Notice the large living room windows. Interior features emulate a historical hacienda with corner kiva-style fireplaces as well as hand-smoothed plaster walls and wood beams. (Courtesy of Mark Jackson.)

This photograph taken about 1950 showcases some decorations at the Guymons' Halloween party. This ghoulish ghost must have scored; Halloween continues to be a very special time in Mission Hills with decorations and lights at many houses, trick-or-treating, and the West Lewis Commercial District block party. (Courtesy of Janed Guymon Casady.)

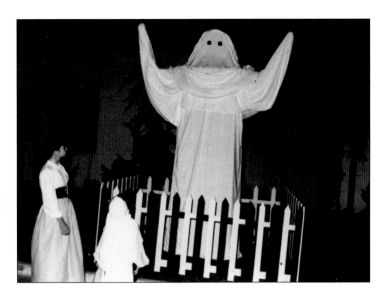

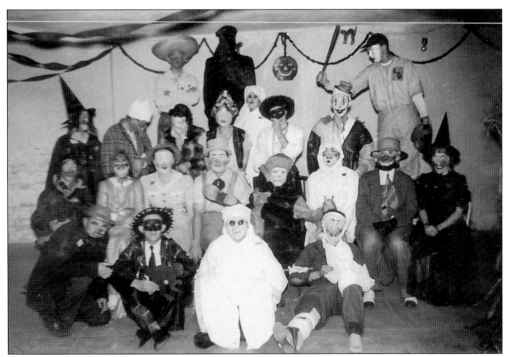

This is a photograph of a 1950s Halloween party at the Mission Hills Methodist Church. Some debuted rather interesting and scary costumes, including a witch, several hobos, a baseball player with a painted face, a clown, and someone dressed in all black with a black mask. (Courtesy of MHMC.)

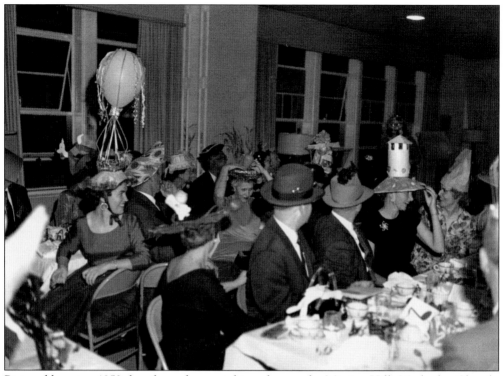

Pictured here is a 1950s hat-themed party taking place at the Mission Hills Methodist Church. Families represented include Bob and Mary Bohler, Jack and Pearl Cranston, Olive and Dick Stafford, Howard and Lauretta Pharis, the Prestons, the Caldwells, and others who attended the Methodist church in the 1950s. (Courtesy of MHMC.)

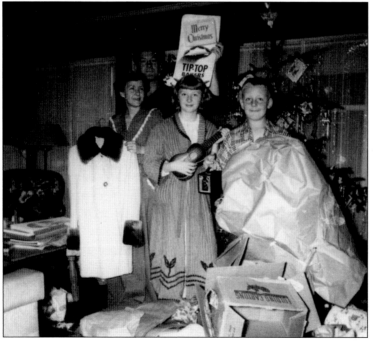

Pictured after opening presents on Christmas around 1955, members of the Baker family are parents Virginia and George Sr., Bette, and George. The family lived on Washington Place, and their family Christmas card reads: "On Dancer, / On Prancer, / On getting on given. / This is what us Bakers call livin' / We sure have a lot of real world folks, / to remember us, California blokes." (Courtesy of Bette Baker Bouchér.)

Six

CHILD'S PLAY

Around the late 1950s, Nita and Dale Clark (diver) splash around with girlfriends at their Spanish Revival home at 4274 Randolph Street. Dallas Clark was a captain in the US Army. The Clarks were both involved with the San Diego Natural History Museum, the Old Globe, and the San Diego Trust and Savings Bank, which Clark's grandfather J.W. Sefton established in 1889. (Courtesy of the Dallas Clark family.)

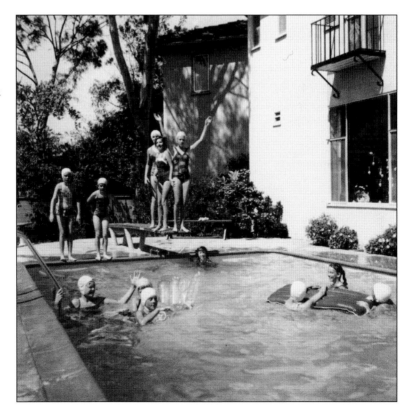

Little Mary Louise Stimson is seen standing atop a concrete cap on a cobblestone pier at a Mission Hills house in 1913. This is an excellent example of the Arts and Crafts movement design feature and practice of using cobblestones found on-site for foundations, chimneys, walls, and pillars. (Courtesy of Erik Hanson.)

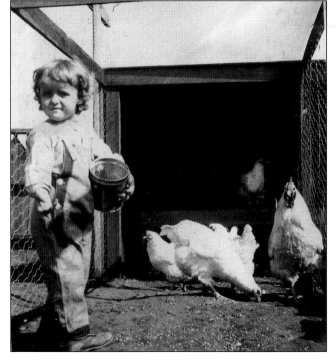

Mary Louise Stimson appears busy feeding the chickens in her parent's backyard. The Stimson family lived in a 1913 bungalow at 4355 Hermosa Way. The Stimson residence lies within the first Mission Hills subdivision, map No. 1115, which was approved on January 20, 1908. Among the apparently ignored deed restrictions was "no male poultry or farm animals of any kind shall be kept on said premises." (Courtesy of Erik Hanson.)

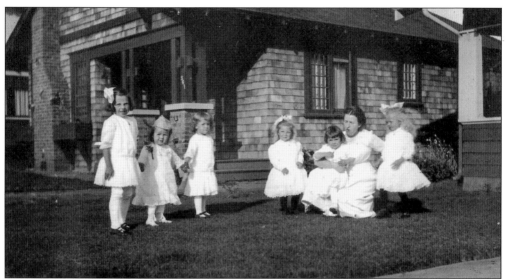

The above photograph, taken about 1913, shows Mary Louise Stimson (third from left) and unidentified friends at her third birthday party at her house on Hermosa Way. Her family's bungalow is mostly out of the photograph, on the right side. The two bungalows to the north are still standing, although altered. At right, Mary Louise Stimson (right) plays dress-up with neighborhood friends Gwendolyn and Beth in her backyard playhouse that was set up in the Stimson's canyon lot. (Courtesy of Erik Hanson.)

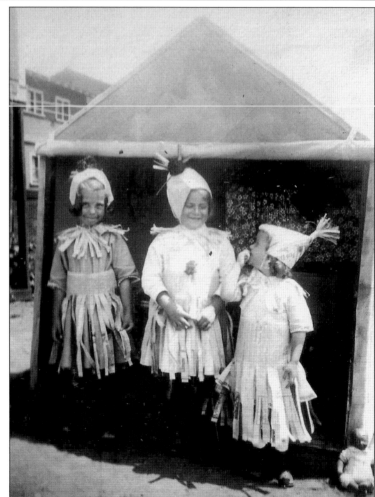

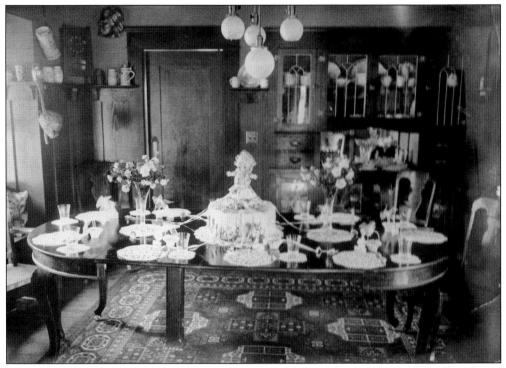

The Stimson table is all set for a party, likely for their daughter Mary Louise. The Arts and Crafts interior of the bungalow reveals typical Craftsman details, including Douglas fir woodwork, a dining room sideboard with leaded glass panels, high wainscoting with a plate rail, and a window seat to the left. Unfortunately, the interior features of this particular house were removed during a major remodeling. (Courtesy of Erik Hanson.)

Mary Louise Stimson is seen standing between her parent's bungalow on Hermosa Way and her neighbors to the left in 1913. Notice the Craftsman houses in behind her across the canyon. (Courtesy of Erik Hanson.)

Mary Louise Stimson stands excitedly next to the Christmas tree around 1915. Notice the candles on the small Christmas tree. Mary Louise received a lot of dolls from Santa Claus this year, as well as a toy telephone and maybe even a toy broom. (Courtesy of Erik Hanson.)

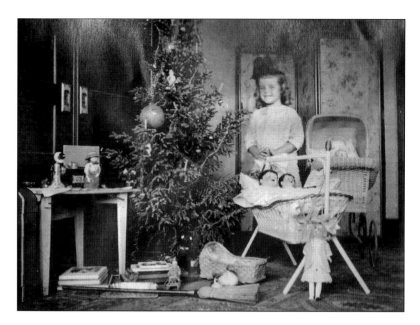

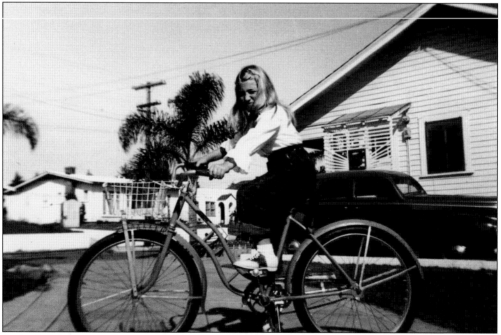

Sarita Jo Mattson is shown on her bike, sometime in the 1950s, in front of 3665 Jackdaw Street. This area is now considered South Mission Hills, the area south of Washington Street. The Jackdaw bungalow court was formed and developed by sisters Mary and Julia Pickett within the original subdivision called Marine View. The bungalows across the street still exist; the bungalow to Sarita's right has been greatly altered. (Courtesy of Sarita Jo Mattson.)

This is a 1925 photograph of Jane Vinton and her doll in the front yard of the Vinton family home at 4470 Hermosa Way. The background shows a two-story Craftsman home and garage built by Mission Hills resident and builder John S. Graves. (Courtesy of Cindy Williams.)

The cast of a mid-1940s Christmas play at the Mission Hills Methodist Church poses in a nativity scene. Sharon Hicks (second row, second from the right) and her family lived just a few doors down from the Methodist church. (Courtesy of Sharon Hicks Anderson.)

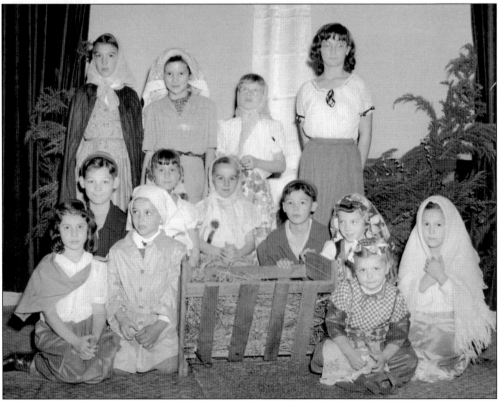

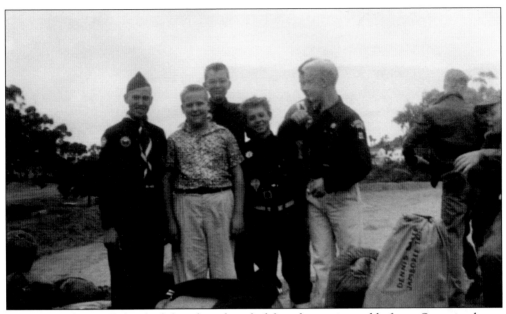

Boy Scouts George Baker (right) and unidentified friends are pictured before a Scout jamboree trip. George and his sister Bette lived on Washington Place. Like many Mission Hills children in the 1950s, they were active with church and Scouting. (Courtesy of Bette Baker Bouchér.)

This is a photograph from December 1951 at Winter Camp in Santa Ysabel for the Mission Hills Boy Scout Troop No. 59. Santa Ysabel is located in east county San Diego, near Julian, with plenty of hiking and campgrounds for the active Boy Scouts. (Courtesy of Bette Baker Bouchér.)

In this 1950s image, George Baker was just back from camping with the Boy Scouts and Bette indicates that he needs a bath. George would later become an auditor, and Bette would go on to a career as a teacher with the San Diego Unified School District. (Courtesy of Bette Baker Bouchér.)

This is an early-1950s photograph of George Baker (holding the child) and unidentified friends in front of the Baker family's bungalow at 1844 Washington Place. (Courtesy of Bette Baker Bouchér.)

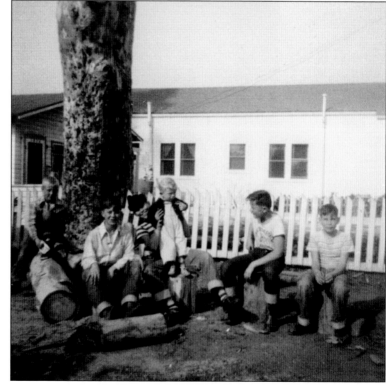

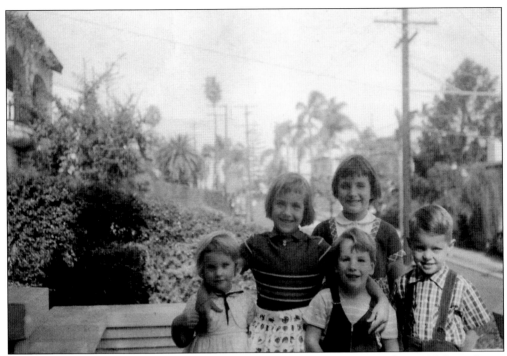

This is a November 1958 photograph of neighborhood children gathered at 4025 Saint James Place. Pictured are, from left to right, Emily Wilkins, Leslie Porter, Anne Porter, Doug Wilkins, and Steve Porter. The Porter family lived in the Prairie School house on St. James Place for many years, and their home was a popular hangout for many kids. (Courtesy of Steve Porter.)

Bette Baker stands in front of the Mellos family residence across the street on Washington Place in 1949. (Courtesy of Bette Baker Bouchér.)

Sharon Hicks (front) and Rose Marie Tait Evans pose in front of 4016 Lark Street in December 1952. (Courtesy of Sharon Hicks Anderson.)

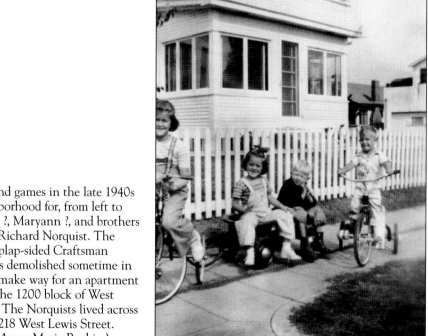

It is all fun and games in the late 1940s in this neighborhood for, from left to right, Margie ?, Maryann ?, and brothers Charles and Richard Norquist. The two-story shiplap-sided Craftsman bungalow was demolished sometime in the 1950s to make way for an apartment complex on the 1200 block of West Lewis Street. The Norquists lived across the alley at 1218 West Lewis Street. (Courtesy of Anne Marie Boykin.)

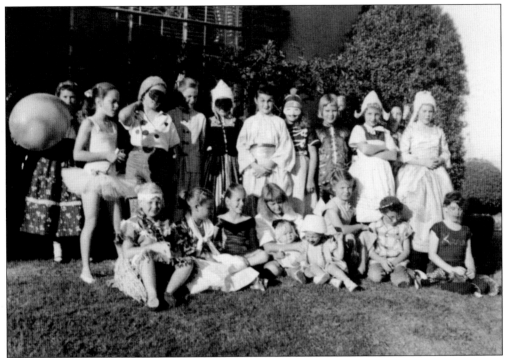

This is a late-1950s photograph of Nina Barton's birthday party at her house at Sunset Boulevard and St. James Place. Nina is holding her friend Franya in the middle of the first row. Cristopher Cyra is just to the right of Nina. Others identified are Mary Alice McBride in the Martha Washington costume; Elizabeth Best in the Japanese kimono; Paula Winder dressed up as Pocahontas; and Chere Ferris as a pioneer. (Courtesy of Nina Barton Owens.)

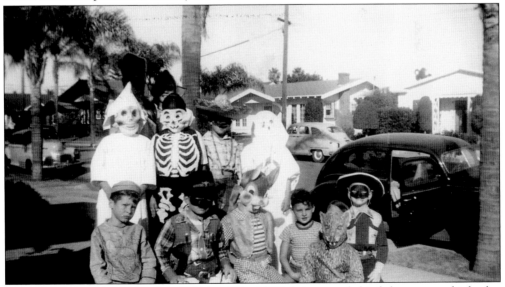

This photograph from October 1949 is of David Hicks's seventh birthday party, which also happened to be on Halloween. Sharon and David Hicks lived on the 4000 block of Lark Street. Some Halloween costumes include three cowboys, a rabbit, a leopard, and two ghosts. (Courtesy of Sharon Hicks Anderson.)

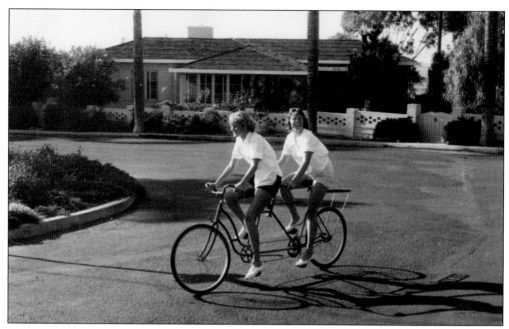

This is a 1959 photograph of Nina Barton (left) and Mary Alice McBride on a tandem bicycle at the west end of Pine Street and Conde Street. Like the lower ends of many parts of Mission Hills, this street has homes built later in the development of the community, including postwar, custom-designed homes such as the one behind the cyclists. (Courtesy of Nina Barton Owens.)

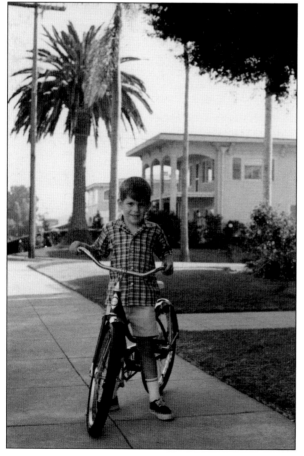

Pierre Charmasson is seen in front of his parents' home at 4102 Saint James Place. The house in the background was likely built by and lived in by Morris B. Irvin and his wife, Ida. They arrived in 1912 or 1913 and established the Irvin Security Company on April 13, 1915, as a contracting firm that bought, sold, and built properties. He was responsible for designing 125 homes in Mission Hills, mostly in the Mission and Spanish Revival styles. (Courtesy of Mari Charmasson.)

Seven

BUSINESSES AND ARTISTS

Sharon Hicks stands at the mailbox along the 800 block of Washington Street before the facade was covered and modernized in the mid-1950s. Some of the shops are Lottermoser's Correct Shoes, Pudge's Tavern (far left), Henderson Bakery, Toy Hoo Chinese Hand Laundry, Save Mor Meat Market (middle), a radio and television shop, a beauty shop, and Falcon Liquor, which is still in business today. (Courtesy of Sharon Hicks Anderson.)

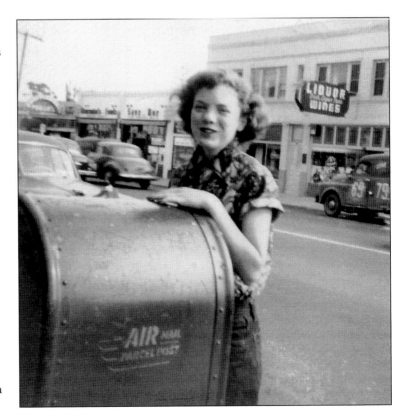

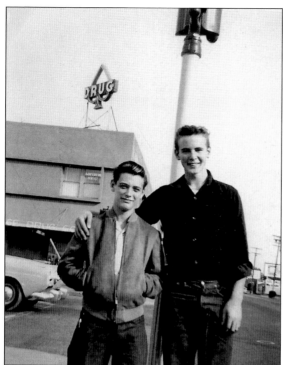

This 1952 photograph of Jim Shreave (left) and Jack Kunce at the corner of Goldfinch Street and Washington Street shows the Ace Drug Store sign above them. The first pharmacy was the Irwin & Lensing Drug Store (1916–1922), followed by Noyes Pharmacy. Ace Drug Store occupied this site from 1928 until 1984. By 1952, the brickwork of the 1912 Griswold Building, built by the Western Building Company, was covered to modernize it. (Courtesy of Sharon Hicks Anderson.)

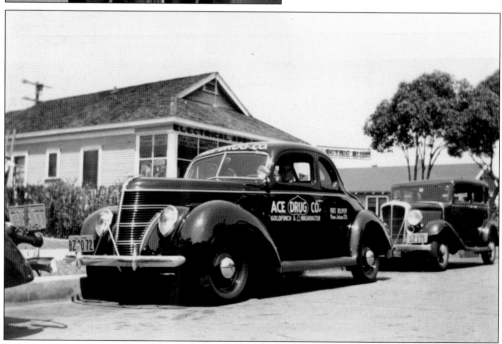

T. Donald Perkins is pictured in his car. In 1925, he purchased the Goldfinch Pharmacy at the corner of Washington and Goldfinch Streets and changed the name to Ace Drug Store. The store sold prescriptions, and had a soda fountain, cosmetics counter, and post office, as well as housing a local branch of the public library when it moved from Ulysses S. Grant Elementary School. Bob and Betty Baker later ran the Ace Drug Store for 42 years. (Courtesy of the Baker family.)

This early 1940s photograph was taken looking east on Washington Street from Hawk Street. The businesses along Washington Street include gas stations, liquor stores, and Ace Drug Store on the north side of the street. Beauty salons, real estate offices, and upscale restaurants in the small but vibrant commercial center have replaced the liquor stores. (Courtesy of the San Diego History Center.)

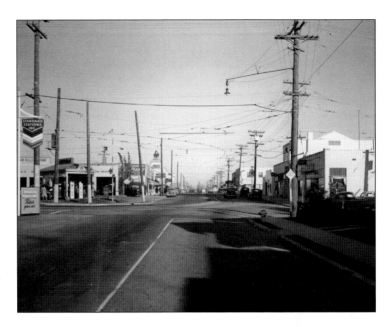

The 1912 Griswold Building and the 1927 Spanish Revival Florence Apartments were built by Columbus F. Stephens and anchor the commercial area along Washington Street, between Goldfinch and Falcon Streets. In 1952, the Funcheons purchased the block, covered the facade to connect the buildings, and renamed it the Mission Hills Shopping Center in an attempt to presumably compete with shopping malls developing in Mission Valley. This recent photograph shows the Florence apartment building after the 2009 restoration.

This recent photograph shows the Rigdon Building located in the quaint West Lewis Street Shopping District before shops are open for business. In 1912, Nathan Rigdon built the hollow clay tile building for $12,000. It featured six furnished apartments above five stores. At the time of its construction, it rested at the western terminus of the Mission Hills streetcar line and opposite Kate Sessions's growing grounds.

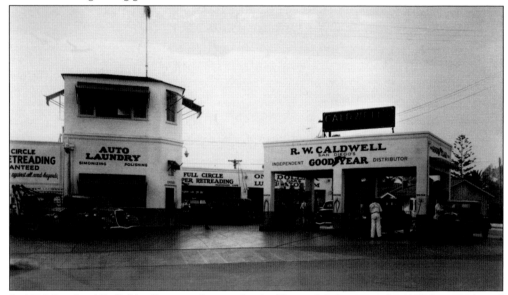

In 1920, Rowland R. Caldwell was a salesman for the Union Oil Company. In 1925, he was elected to head the Mission Hills Businessmen's Association and operated as a Goodyear distributor. He was given the unofficial title the "Mayor of Mission Hills," which is reflected in this 1930s photograph of the service center and sign at 1111 Fort Stockton Drive. (Courtesy of the San Diego History Center.)

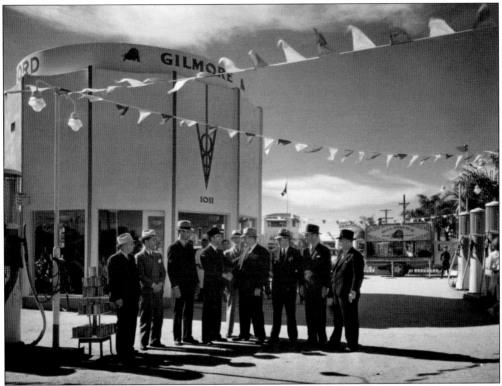

In 1935, the Neuner Brothers dealership debuted at 1011 Fort Stockton Drive. It featured Ford products and was modeled after the famous Streamline Moderne Ford Building showcased at the 1935–1936 California Pacific International Exposition in Balboa Park. The photograph shows the 1935 dedication of the dealership. (Courtesy of the collections of The Henry Ford.)

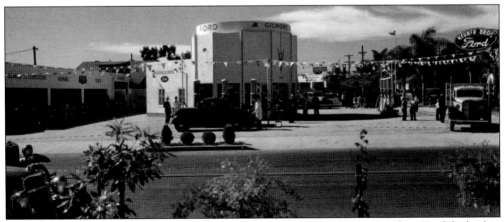

This is a 1935 publicity photograph of the grand opening of the Neuner Brothers Ford dealership and gas station seen from along Hawk Street. Currently, the buildings to the left are automobile repair shops. Notice the streetcar tracks along Hawk Street, the children attracted to the caged lion in at the back of the lot, and the bungalows at the far right, since demolished for the Ibis Market. The Craftsman house to the left was demolished for the 1970s Green Manor. Caldwell's Goodyear service station is in the distance. (Courtesy of the collections of The Henry Ford.)

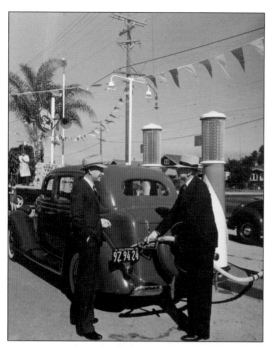

During the Great Depression, noted American industrial designer Walter Dorwin Teague designed the iconic Ford Building in Balboa Park for the 1935 California Pacific International Exposition. This 1935 publicity photograph of the Neuners Brothers dealership shows officials pumping gas along Hawk Street. The bungalows in the background on Hawk Street and Fort Stockton Drive have been demolished and replaced by a strip mall. (Courtesy of the collections of The Henry Ford.)

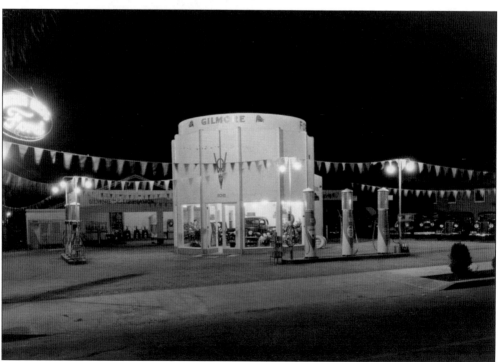

This is a 1935 nighttime publicity photograph featuring the Neuner Brothers Ford dealership and gas station with its glowing neon sign. In 1934, Ford hired Albert Kahn to design the 1934 Chicago World's Fair Ford Rotunda. It resembled graduated internally meshed gears standing 12 stories high. Ford also exhibited at the Dallas Centennial Central Exposition (1936–1937) and both New York world's fairs (1939–1940, 1964–1965). (Courtesy of the collections of The Henry Ford.)

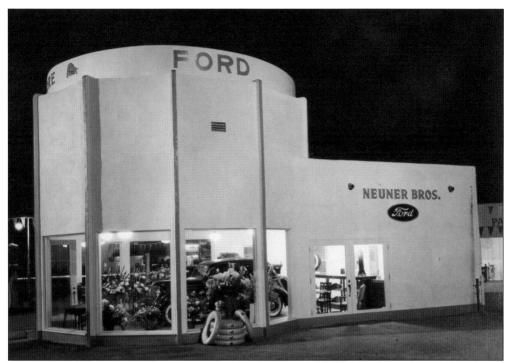

This is a 1935 nighttime publicity photograph of the Neuner Brothers Ford dealership revealing the 1936 model Lincoln-Zephyr V-12 automobile in the rotunda-like showroom. Louis J. Neuner was born in 1894, and he and his wife, Marie, lived at 4691 Harvey Road along with their daughter Margaret, a bookkeeper. They also had Ford dealerships at 1276 and 3940 University Avenue. (Courtesy of the collections of The Henry Ford.)

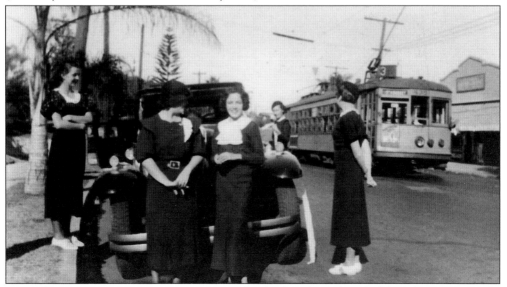

Around 1936, Detty June Stevenson is pictured in back with unidentified friends across from the Mission Revival commercial building erected by Carl Leuders at 1920–1926 Fort Stockton Drive as the No. 3 streetcar goes by. In the 1950s, local boys infuriated the neighborhood when they set off an explosion that damaged the soda fountain of what was then Buss's market.

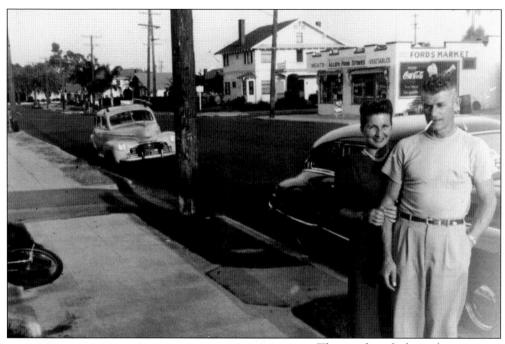

This unidentified couple poses about 1947 in view of Ford's Market along West Lewis and Jackdaw Streets, then owned by a Mr. Cherry. Notice the crenellated parapet on the market. Ford's Market was demolished to make way for the United Church of Christ parking lot. In the distance are several bungalows at the present-day location of the St. Vincent de Paul Catholic Church. (Courtesy of Anne Marie Boykin.)

This is a 1979 photograph of longtime resident Nina Barton Owens at the Good Life Food Co-op on West Lewis Street. Leo Finegold started the co-op in the late 1970s and managed it. In the early-morning hours, Nina and others would pick up crates of fresh fruits and vegetables from farm distributors for the approximately 350 member families. (Courtesy of Nina Barton Owens.)

In 1925, Kate Sessions sold her nursery to Giuseppe "Tony" and Pasquale "Anton" Antonicelli. They first met Sessions in Italy and arrived here in 1911 as her protégés. The Antonicellis moved the nursery a few blocks south to 1525 Fort Stockton Drive and renamed it the Mission Hills Nursery. Pictured here is Giuseppe's son Frank, who owned the nursery until 1995, when Fausto and Toni Palofox bought Mission Hills' oldest business. (Courtesy of Fausto Palofox.)

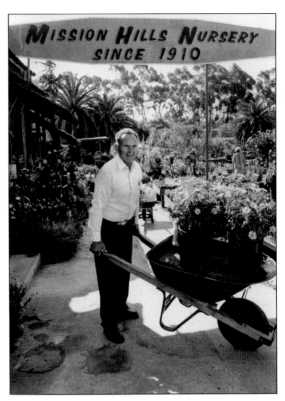

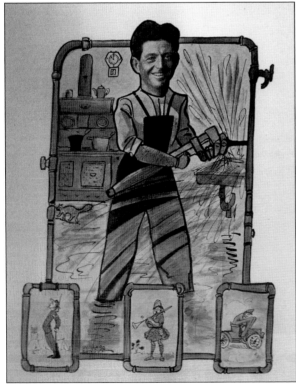

Fred A. Heilbron has been called San Diego County's water crusader. He arrived in San Diego in 1888 and started his own plumbing company in 1902 on Fifth Street, which operated for over 80 years. In 1916, he passed the bar exam and became a lawyer. He served on the city council and was responsible for bringing San Diego water from the Colorado River. Heilbron lived at 4399 Hermosa Way.

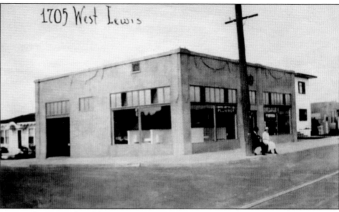

In 1923, Luther Powers commissioned master builder Martin V. Melhorn to construct the Spanish Revival plumbing shop. Powers Plumbing has operated there ever since. Luther Powers grew up on a farm in Kansas and married Anna Lightburn in 1890. They had five children, including Calvin, who became his father's business partner. This 1920s photograph is shown side by side with a 2014 painting of the shop at dusk by artist Elizabeth Weems. (Right, courtesy of Melhorn Construction.)

This is a 1918 photograph of Calvin "Cal" Powers posing for the San Diego Rowing Club at age 20. In 1917, his father Luther moved his plumbing business to Mission Hills from Eighth Street downtown. Cal joined the family business and eventually took over for his father. Powers Plumbing is the second-oldest business in Mission Hills, just behind the Mission Hills Nursery. (Courtesy of Stephanie Loomis.)

This photograph shows a 1920s bungalow at the corner of Alameda Drive and Henry Street during the early 1970s. Convair General Dynamics (middle right) was a major employer during the postwar years. Known as Consolidated Aircraft Corporation during World War II, it was a builder of military planes. Beyond the view of downtown, the 1969 Coronado Bay Bridge is seen in the distance.

This is a photograph of a 1999 placemat created by Cheryl Clark to publicize the Mission Hills Garden Club's annual garden walking tour. It depicts some of the street life that one would see when touring the neighborhood during the garden walk and brings attention to many local shops and businesses. The annual Mission Hills Garden walk began in 1998 and supports local projects that benefit the community. (Courtesy of Cheryl Clark.)

John Vance Cheney (1848–1922) lived at 1816 Sheridan Avenue in a 1909 Craftsman house designed by Emmor Brooke Weaver. Cheney was a nationally known poet, essayist, and librarian. There was a John Vance Cheney Day on November 30, 1916, at the Panama California Exposition. Locally, he wrote poems about Presidio Hill, Old Town, Padre Junipero Serra, the lone pine tree at Torrey Pines State Natural Reserve, and the San Diego Mission.

Around 1910, the Hillside Colony of artists was formed off of Titus Street. It began as a series of cheap-rent barracks and a recreation room from Camp Kearny. Small cabins were added in the 1920s and 1930s. The bungalows and landscape featured cobblestone work. This is a photograph of a small tile that may be all that remains of the site; it was demolished for condos in the 1980s.

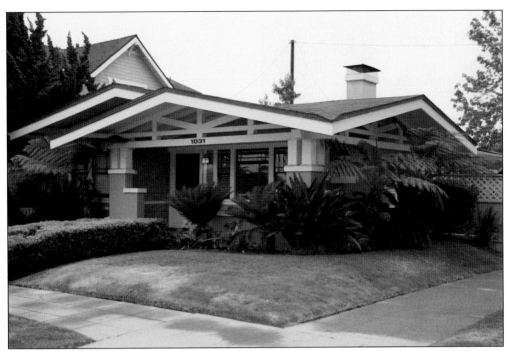

During the 1915 Panama California Exposition, artists gathered at writer Bertha Bliss Taylor's white bungalow at 1031 Hunter Street for poetry reading. A poem about the place by Grace Sherburne Conroe published in *Exposition Memories San Diego 1916* reads as follows: "Little white bungalow / Perched on a crest. / Viewing the valley, / Symbol of rest. / Strangers have loitered here, / Friendships have grown, / Yielding so quickly, to / Love's undertone. / Dear little inmate, / Helpfully kind. / Serving in gentleness, / Culturing mind. / How shall we cherish thee, / Ages to come, / When He in wisdom / Bids thee come home."

Hope Mercereau Bryson was born in 1887. She studied at the National Academy in New York and the Corcoran School in Washington, DC, and then studied portrait work in Paris under Henri Morrisset. In 1925, she arrived in San Diego. She lived at 4291 Hermosa Way through the 1930s. Bryson was a member of the Laguna Beach Art Association, San Diego Art Guild, and the Berkeley Art Guild. She exhibited frequently. (Courtesy of the San Diego History Center.)

Orlando Giannini (1860–1928) was a seminal Prairie School artist best remembered for his association with architects Frank Lloyd Wright and George Washington Maher. He painted several famous murals in Wright's Oak Park home. He also designed art glass windows, fireplace tile mosaics, and Teco glass lampshades before moving to San Diego in 1907. In 1912, he designed a Prairie School home at 4033 Alameda Drive, including its organic planters seen here.

To support herself during the Depression, Belle Baranceau began a long career in education. She first taught in Chicago's Jewish community and locally at Francis W. Parker School from 1946–1969. From 1962 until 1980, she lived at 1010 West Lewis Street. Baranceau passed away in 1988. Her paintings have been exhibited at the Art Institute of Chicago, Carnegie Institute, the Los Angeles County Museum of Art, Denver Art Museum, and other museums. (Courtesy of the San Diego History Center.)

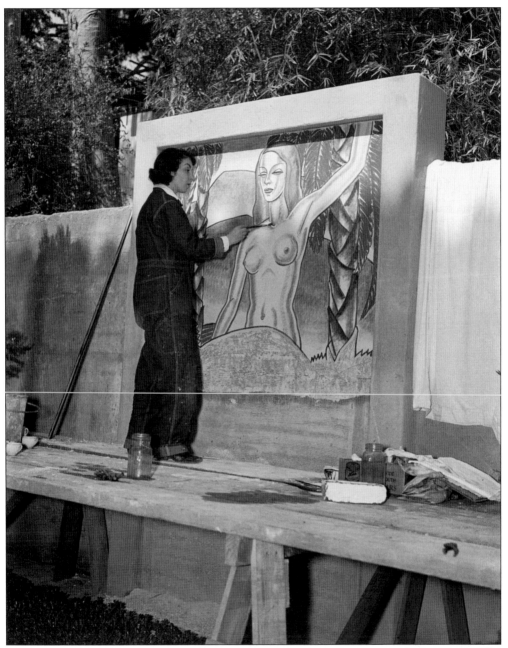

This is a mid-1930s photograph of Belle Baranceau, one of San Diego's most famous artists. She was born in Chicago in 1902 and studied at the Minnesota School of Art and the Art Institute of Chicago. In 1933, she arrived in San Diego. She painted murals for the La Jolla Post Office (1935–1936), two school murals for the Works Progress Administration at Roosevelt Junior High (now at the San Diego History Center), and La Jolla High (demolished). (Courtesy of the San Diego History Center.)

Attributed to William Templeton Johnson, this 1912 Italian Renaissance structure at 4159 West Montecito Way was completely rebuilt in the 1980s. Clara Barck Welles (1868–1965) lived here after she retired in the 1940s from Chicago's Kalo Shops. In 1900, Welles founded the Kalo Shops in Park Ridge, a suburb of Chicago, and it became one of the leading Arts and Crafts silversmith shops in America.

Leon Bonnat's 1875 painting of a *Roman Girl at a Fountain* inspired the beautiful Spanish Revival tile plaque that is applied to the Mariano Escobedo house on Sunset Boulevard and reportedly at the Jai Lai Palace (built 1926–1947) in Tijuana. Escobedo owned the Jai Lai Palace.

Eight

FROM BUNGALOWS TO MODERN HOMES

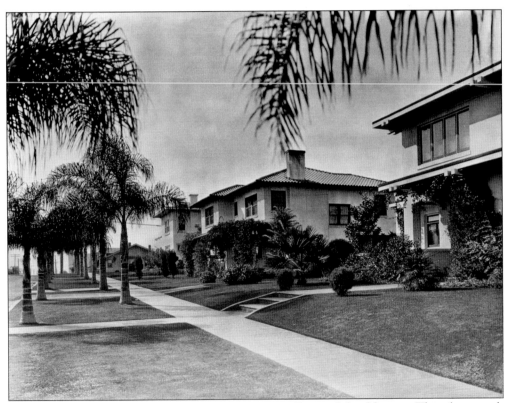

The 4100 block of Lark Street features six impressive Prairie School houses. This photograph shows the 1915 Elliot-March House at the right, built by Joel L. Brown. The low-hipped or flat-roof houses with stucco exteriors, bands of windows, and overhanging eaves offer a local interpretation of this Midwestern style. The block led to Kate Session's lath packinghouse. (Courtesy of the San Diego History Center.)

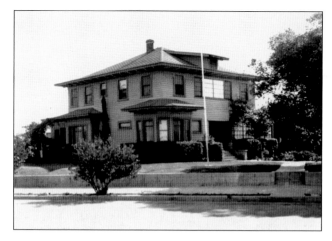

This is a photograph of the 1910 John Lincoln Kelly and Ethel Kelly Residence at 4229 Saint James Place. Kelly arrived in Old Town in 1868. Along with George Marston, he was part of the real estate syndicate that founded the 1908 Mission Hills subdivision. He was an authority on San Diego and California history and was credited for convincing George Marston to preserve Presidio Hill. Kelly died in 1938. (Courtesy of Valerie Schwartz.)

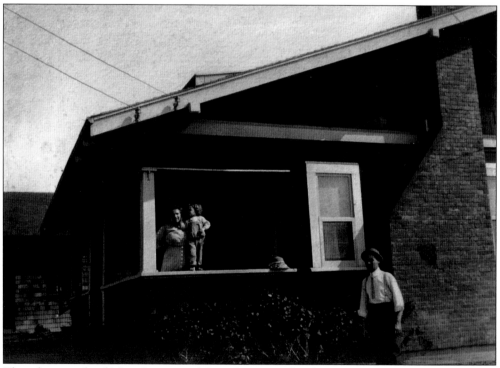

This photograph of Mary Louise and Burt Stimson's daughter Mary was taken at their 4355 Hermosa Way bungalow around 1916. The Stimsons lived there for three years. The builder is unknown. Redwood shiplap siding was used on the bottom portion of the bungalow, with vertical wood shingles used above the course line. The hipped roof with exposed rafter tails and wide overhanging eaves are also architectural characteristics of 1910s bungalows across America. (Courtesy of Erik Hanson.)

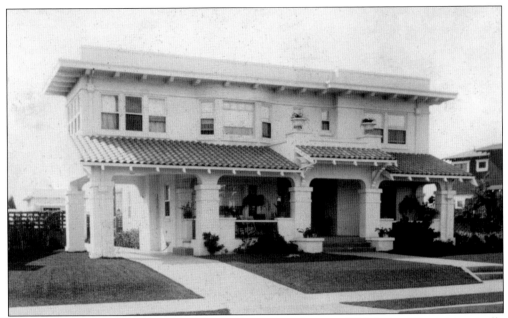

The Della M. Ballard House, a 1913 Mission Revival residence at 4220 Arden Way, is historically designated. The first owner was Fred Ballard, president of Ballard and Brockett, a popular clothing store downtown. The builders were Edward Rambo, who lived next door, and Moritz Trepte. Distinctive features include a full-width front porch, which terminates into a porte cochere. The shed roof has red tiles and prominent cornices beneath the overhanging eaves. (Courtesy of Jim Wiesler.)

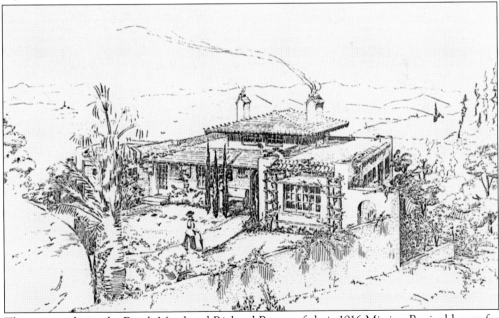

This is a rendering by Frank Mead and Richard Requa of their 1916 Mission Revival house for Robert C. Gemmell at 4476 Hortensia Street. Gemmell was a general manager of a Utah copper company. Before their eight-year partnership, Mead and Requa had worked in Irving Gill's office; Mead later briefly formed a short partnership with Gill. (Courtesy of Peter and Laura Wile.)

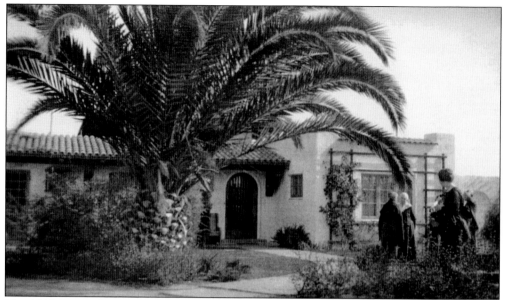

The 1916 Gemmell House features Mead and Requa's interest in North African, Spanish, and Mediterranean styles with the arched door with wooden spindles, the red roof tiles, and massive sculpted brackets. Requa built his own Mediterranean-influenced home in Mission Hills in 1912 at 4346 Valle Vista. Requa was later the master architect of the 1935 California Pacific International Exposition in San Diego's Balboa Park. (Courtesy of Peter and Laura Wile.)

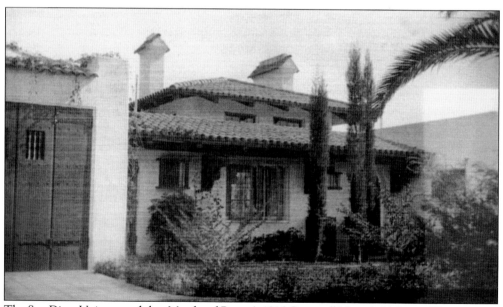

The *San Diego Union* stated that Mead and Requa's 1916 Gemmell House's 16-foot-tall living room would admit "an abundance of light and air through the windows . . . A rare old life-size painting will be built into north side of the living room. The entrance hall, living and dining rooms will all be high wainscoted in Philippine mahogany." (Courtesy of Peter and Laura Wile.)

This photograph shows the 1919 Harmon House at 1840 West Montecito Way. The Craftsman house features pyramidal porch supports, low-hipped three gable roof line, Chicago-style windows, and wide, overhanging eaves with brackets and vertical wood shingles. West Montecito Way also features low cobblestone walls along the parkway that were originally built during the 1910s. In 1920, Fredrick Harmon sold his home to Scott A. Palmer, the owner of downtown's Savoy Theatre. (Courtesy of Victoria Reed.)

This image is from a lantern glass slide and shows the 1917 Prairie School house built by Martin V. Melhorn on Alameda Drive. The first owners were Irving and Anna Brockett. The Bracketts partnered with Fred C. Ballard in the prestigious men's clothing store Ballard & Brockett, located downtown. The Bracketts had three children, and their son Sheldon would become a well-known local dentist and lived in a Lloyd Ruocco Modernist house at the end of Trias Street.

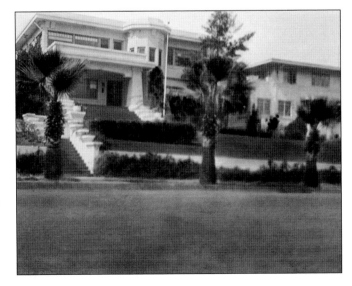

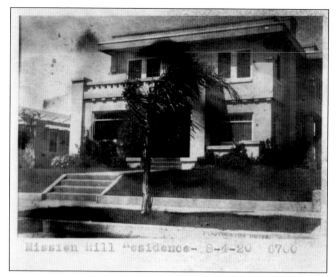

This postcard of 2206 Fort Stockton Drive shows a 1917 Prairie School, historically designated house built by master builder Nathan Rigdon. Rigdon contributed to the distinctive appearance of Mission Hills by building several regional interpretations of the Prairie School style, which was developed in the Midwest by Frank Lloyd Wright, Walter Burley Griffin, William Drummond, Marion Mahony, and others. The house lies within the Fort Stockton Line Historic District.

In 1926, John F. and Martha T. Forward Jr. bought this Prairie School house at 4144 Lark Street. He was vice president of Union Title and Trust Company, mayor of San Diego from 1932–1934, and vice president of the 1935–1936 California Pacific International Exposition. This 1935 photograph may have been taken after Mayor Forward sustained an automobile accident. Afterwards, he conducted city business from his bedroom in this house. (Courtesy of the San Diego History Center.)

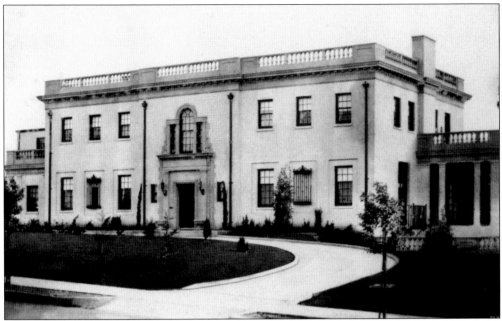

An early view of the 1921 Italianate E.T. Guymon House at 2055 Sunset Boulevard captures the home before the stone fence was built around the perimeter. It was designed by Los Angeles–based Robert Raymond. Raymond was also responsible for several community buildings in Santa Paula. He was born in New York in 1893, served in the US Navy during World War II, and is buried at Fort Rosecrans National Cemetery. (Courtesy of Janed Guymon Casady.)

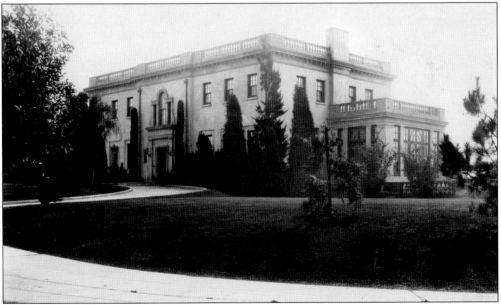

Pictured here again is the Guymon House as seen in 1923, before the massive stone fence walled off the view of the property. Guymon Jr. was a well-known collector of first edition mystery novels. At onetime, he had over 20,000 books in his library, including first editions by Edgar Allan Poe and Dashiell Hammett. Guymon was a member of the Baker Street Irregulars, a society devoted to Sherlock Holmes. (Courtesy of the Vecchione family.)

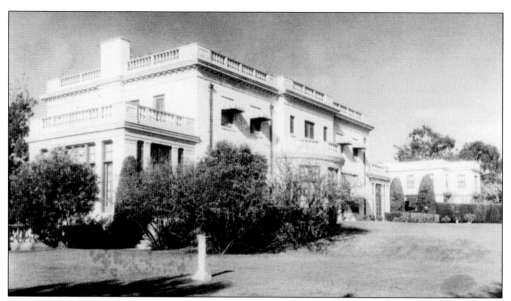

This 1923 photographs shows the northeast facade of the Italian Renaissance Guymon House. Italian Renaissance features of this house include the flat roof, detailed cornice, roofline balustrades, and symmetrical facade. This style's popularity declined in the 1930s. The structure to the right is the two-story garage with the second floor used for staff housing. (Courtesy of the Vecchione family.)

This is an early-1920s photograph of the drawing room in the Guymon House. Besides the opulent antique furnishings, other items of note include the coved ceiling, massive Batchelder tile fireplace, and the tapestry above it. Edward T. "Ned" Guymon was the president of the Townsite Company, and Guymon, Oklahoma, was named after him. In 2012, that town had almost 12,000 residents. (Courtesy of the Vecchione family.)

Ned Guymon was born in Illinois in 1859. At age 21, he sold a cow for $22 to pay his fare west. In the 1890s, he purchased land in the Oklahoma Panhandle, later establishing the Star Mercantile and becoming the first president of the City National Bank. This photograph shows the dining room of the Guymon House with its Batchelder fireplace, antiques, chandelier, wall sconces, and ceiling medallions. (Courtesy of the Vecchione family.)

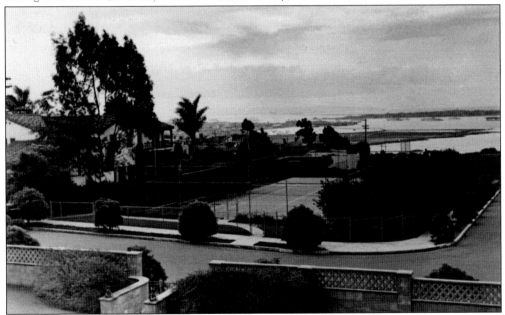

This photograph is a 1930s view from the back of the 1921 Guymon House. To the left is the 1927 Guilford H. and Grace Whitney Spanish Revival house, designed by Ralph E. Hurlburt and Charles H. Tifal. The tennis courts were sold off and a new Craftsman Revival home was built on that lot in the 1990s. Several battleships appear to be in the San Diego Bay. (Courtesy of Janed Guymon Casady.)

Master builder Morris B. Irvin designed the 1924 Mariano Escobedo House on Sunset Boulevard near St. James Place. These recent interior photographs show the original hand-stenciled scenes in the living room of this residence. It is unknown who created the elaborate stencil work. Irvin built at least 10 other Mission and Spanish Revival homes in the immediate area.

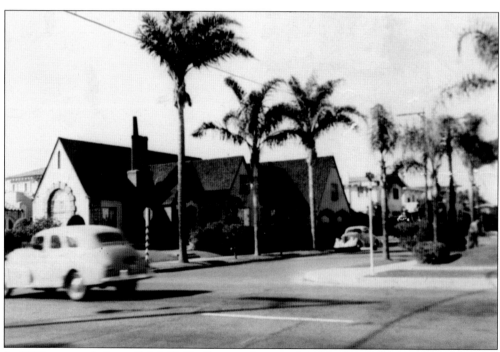

In 1925, master designer Ralph E. Hurlburt and master builder Charles H. Tifal designed this English Tudor Revival house for Ed Jacobson for $30,000 at 4204 Saint James Place. An early resident was A.J. Cohn, vice president of the International Packing Company and Van Camp Seafood Company; he retired from the fishing industry in 1932. Dr. Robert E. and Marcella R. Barton moved into this house in the early 1950s. (Courtesy of Nina Barton Owens.)

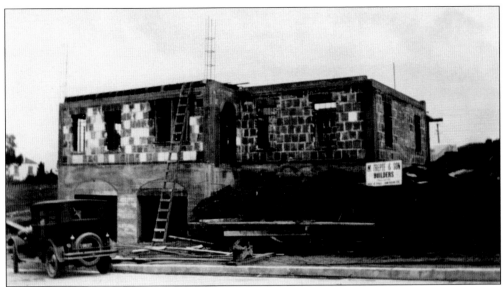

This is a 1926 photograph showcasing the hollow clay construction of the William Templeton Johnson/Moritz Trepte historically designated house. Located at 4467 Ampudia Street, the Spanish Revival design is by one of San Diego's greatest architects, who happened to live around the corner on Trias Street. Trepte Construction built the home and the family lived here until 1952. (Courtesy of Colleen O'Malley.)

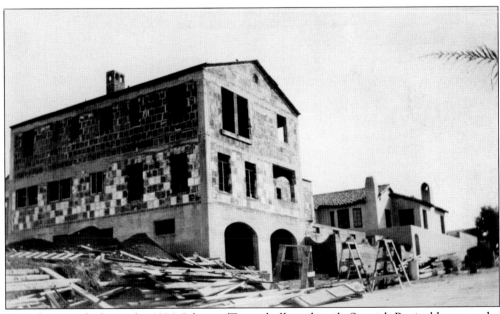

This photograph shows the 1926, Johnson/Trepte hollow clay tile Spanish Revival house under construction. The 1926 Etta and Lydia Schwieder house designed by Henry Jackson and Richard Requa is behind it on Pine Street. The first resident was Moritz Trepte, who founded the Trepte Construction Company in 1895. Trepte and Son built the Third Avenue Ohr Shalom Synagogue and several WPA projects for the 1935 California Pacific International Exposition. (Courtesy of Colleen O'Malley.)

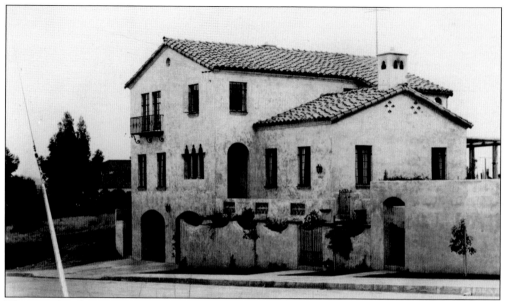

The completed 1926 Johnson/Trepte house was originally designed as an L-shaped form over an attached two-car garage. The house was a Mediterranean-inspired residence with a low-pitched red tile roof, a front balcony, and Moorish arches and columns. Notice the Moorish detail on the chimney. As of 2014, the house has had just three owners. (Courtesy of Colleen O'Malley.)

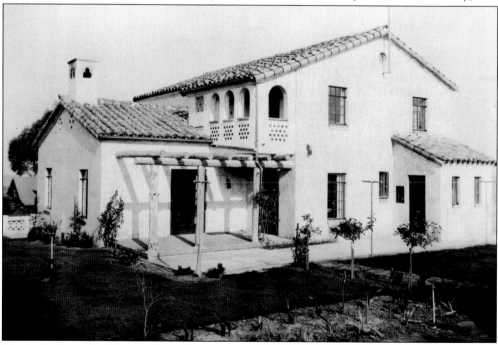

The back side of the Johnson/Trepte house originally featured a pergola as well as Moorish-inspired arches over a balcony off the bedroom. However, these features have been removed for additional square footage. The second owner, Sam Wood Hamill, was also a master architect, associated with William Templeton Johnson and involved on several Balboa Park projects with the 1935 exposition and the County Administration Building (1936). (Courtesy of Colleen O'Malley.)

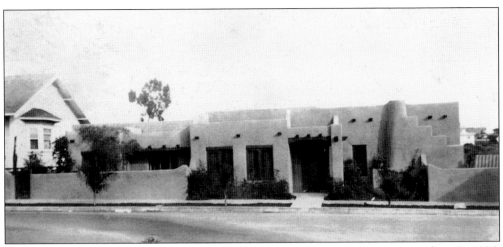

This is an early photograph of a rare Pueblo Revival home at 3939 Saint James Place. In 1926, Stanford graduate Harold B. Starkey commissioned master builder Frank O. Wells to construct this house on the canyon. The home was built for $15,000. Starkey was born in Illinois in 1896, and in 1924, along with his father, he founded the Bay City Building and Loan.

The historically designated Harold B. and Augusta Starkey House is the subject of a May 23, 1926, *San Diego Union* article, which gushes that the Pueblo Revival house is " a replica of the homes of the ancient cliff dwellers of New Mexico . . . there are no sharp corners. This is an innovation of Mrs. Starkey's making the room particularly adaptable, acoustically, for singing."

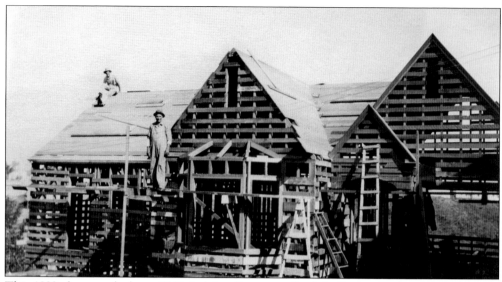

This 1929 photograph shows 3663 Jackdaw Street, an English Cottage under construction by builder Gunnar E. Johnson. Three houses in this bungalow court share the style with asymmetrical facades, sharply pitched roofs, and prominent front bay windows. Julia and Mary Pickett moved to this middle house in 1940; Mary lived here till her death in 1955. (Courtesy of Kirk Bacon.)

This 1930s photograph shows the completed house at 3663 Jackdaw Street owned by the Pickett sisters. The Picketts were both teachers and originally from New Haven, Connecticut. Gunnar E. Johnson built English Cottage–style bungalows for the Picketts, interspersed with the Craftsman bungalows that were already on the property (as seen at the right). Most of the houses were completed in 1929 just before Black Tuesday (the Wall Street crash of 1929). (Courtesy of Kirk Bacon.)

This photograph captures the view from the street of the unique English Cottage bungalow court with a shared driveway off of Jackdaw Street. The 1911 Arts and Crafts bungalow at the left (3667 Jackdaw Street) has been greatly altered. After they purchased the lots in 1921, the Pickett sisters had to move a bungalow (not shown) to create the bungalow court. (Courtesy of Kirk Bacon.)

The 1929 Mary and Julia Pickett House at 3665 Jackdaw Street is in the center of this photograph, with the blimp likely headed to the San Diego Airport. In 1937, US Navy captain William Deragon and his wife, Elizabeth, lived there. Captain Deragon earned two Bronze Stars and a Silver Star during World War II. (Courtesy of Kirk Bacon.)

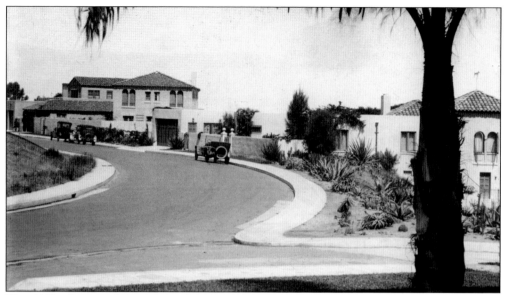

This 1920s photograph from a glass lantern slide shows two William Templeton Johnson Spanish Revival houses along Hermosa Way. The house on the right is the 1922 Sarah Brock/William Templeton Johnson House. The house on the left is the 1923–1927 Marion Delafield Sturgis and Samuel Otis Dauchy/William Templeton Johnson House. Both are historically designated and were built by Harry Brawner. Both homes demonstrate a mixture of Spanish, Moorish, and Pueblo influences.

Ada C. Gilbert is standing in front of her Buick and her 1919 bungalow, built by Morris B. Irvin. Gilbert moved to San Diego from Canada in the early 1920s. She owned Deluxe Cleaners and Dryers on Fourth Avenue and was a plein air artist who exhibited at many shows. In 1945, she married naval officer Vern McGrew. Next door is master builder Alexander Schreiber's 1917 residence. (Courtesy of Melinda Blade.)

This is the 1936 Lorraine and Harold Tucker house designed by Cliff May. It was among several designs by May in the Presidio Hills neighborhood. May's brilliant site plan has the perimeter wall following the curve of Altamirano Way and pushes the house to the rear of the pie-shaped lot. Sam Hamill designed the addition. (Courtesy of Mark Jackson.)

The first residents of this 1925 Spanish Revival house at 1875 Sheridan Avenue by Martin V. Melhorn were Charles and Evelyn McGaughey. He worked as a salesman for the Aber & Rutherford real estate company. They sold the house to Dr. Sami and Julia McClendon in 1928. The McClendons lived here until 1937 when widow Mary Hogg bought the home. (Courtesy of Charles Williams.)

During the 1940s and 1950s, the Norquist family lived in the bungalow shown at right, 1218 West Lewis Street. While the two palm trees are long gone, these homes remain intact with some minor alterations, including enclosed front porches. Notice the interesting diamond pattern on the double-hung windows. The No. 3 streetcar trolley tracks are still visible; they were covered up following World War II. (Courtesy of Anne Marie Boykin.)

This 1940s photograph shows Lillian Norquist with one of her sons in front of their 1218 West Lewis Street bungalow. While the Craftsman across the street on West Lewis Street remains today, the corner bungalow, seen at the far right on Ingalls Street and West Lewis Street, was demolished sometime in the 1950s to make way for an apartment building. (Courtesy of Anne Marie Boykin.)

The Hicks family lived at this house, which was across from Washington Place on Ingalls Street from 1957 to 1959. Sharon Hicks's father sold this house to Ulysses S. Grant Elementary School, which demolished it along with about seven other bungalows to expand the campus. (Courtesy of Sharon Hicks Anderson.)

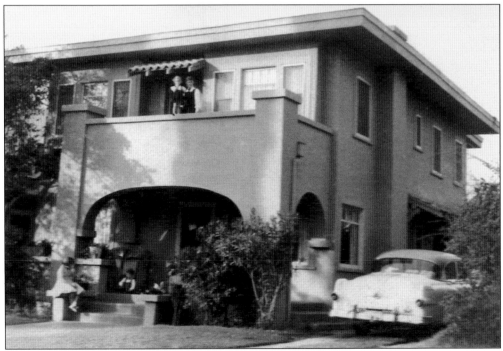

This is a 1950s photograph of the Prairie School house at 1870 Sunset Boulevard designed by Nathan Rigdon for widow Mae Kohler in 1913. In 1919, she sold this house to Milton McRae. He was a famous newspaper publisher involved with the Scripps-McRae League of Newspapers. This was the site of many social gatherings with important local families such as the Wagenheims, Fletchers, Johnsons, Wheelers, and others. (Courtesy of MHMC.)

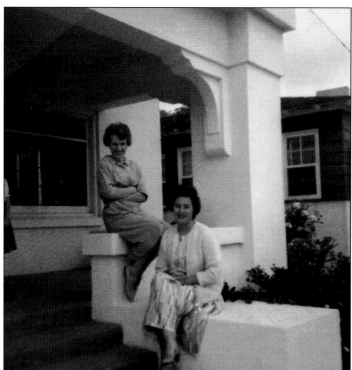

Master builder and Mission Hills resident Nathan Rigdon designed this 1918 Prairie School house at 1882 Sheridan Avenue. It was built for Henry L. and Verna Benbough, who owned Benbough Furniture in downtown San Diego. This October 1962 photograph shows Marne Wilkins and Kathleen "Kay" Porter (right) on the porch. Porter attended San Diego High, was a former president of the San Diego History Center, and has been active with many nonprofit organizations. (Courtesy of Steve Porter.)

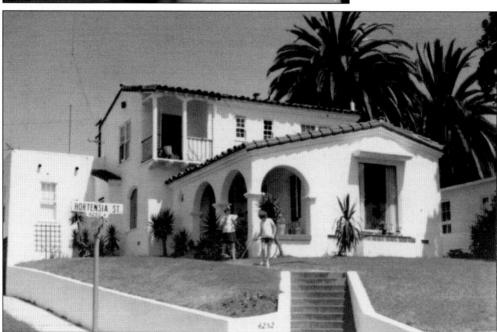

This Spanish Revival house at 4252 Hortensia Street is another house that was built and lived in by Morris B. Irvin. This home features an arched front porch with a Monterey-style second-story balcony. Irvin grew up in Nebraska and worked as a dry goods merchant before arriving in San Diego, where he became a prolific builder. He is mostly recognized today for California Craftsman, Mission Revival, and Spanish Revival single-story houses. (Courtesy of Anthony Spurgin.)

Following the end of World War II, several Modernist architects such as Lloyd Ruocco, Sim Bruce Richards, Homer Delawie, and others would build impressive new homes, which would complement the architectural styles from the prewar era. These photographs show the 1949 Dr. Thomas S. Mooney house at 1820 Neale Street, designed by John Lloyd Wright, son of the famous architect Frank Lloyd Wright. (Courtesy of Steve and Civia Gordon.)

The 1949 John Lloyd Wright organic Modernist home used redwood as the interior wood with a vaulted living room ceiling. This home recalls Frank Lloyd Wright's Usonian houses of the 1930s–1950s. Notice the low-hipped roofline with overhanging eaves and the wood ornament zigzag chain pattern on the roof fascia, which was created from leftover scraps of wood during construction. (Courtesy of Steve and Civia Gordon.)

The 1949 Mooney House zigzag roofline is repeated on the fence. Architect John Lloyd Wright arrived in San Diego in 1910, worked on Harrison Albright's downtown Workingman's Hotel, and designed the Wood House, a Prairie School house in Escondido. In 1914, Wright returned to Chicago to assist his father on Midway Gardens, then he returned to San Diego and moved to Del Mar in 1946. (Courtesy of Steve and Civia Gordon.)

This 1954 ranch-style house at 4119 Bandini Street was the first home built in the Rodefer Hills subdivision. The first owners were Sue J. and Janous Marks; he was a fisherman of Portuguese descent. Postwar ranch-style homes were built down the hill from the older, more established sections of Mission Hills and catered to young families who sought custom-designed contemporary homes that were different from the postwar housing tracts. (Courtesy of Marjorie Marks.)

This is a 2014 photograph of the 1963 Chester and Joanne Haywood House, by Sim Bruce Richards (1908–1983) at 1840 Neale Street. Richards was a leader among the organic Modernist architects in San Diego. He was born in Oklahoma of Cherokee heritage, first designed abstract rugs, then spent two years at Frank Lloyd Wright's Taliesin fellowship program. Richards worked with other artists, including James Hubbell. The Haywood house features Hubbell art glass.

This is a recent photograph of the 1952 Rabinowitz House on Sunset Boulevard by Lloyd Ruocco, which was built on part of the grounds of the former 1912 Milo C. Treat Mansion. Ruocco (1907–1981) designed several Modernist homes in Mission Hills, mostly in the canyons, as it was the only available land after World War II. Ruocco is regarded as the father of San Diego Modernism. His early designs were mostly rustic, using organic materials.

This photograph shows the Modernist house designed by Gin Wong in the early 1960s for Tom and Yuk Lai at 3872 Bandini Street. Wong served as the director of design for the original 1952 Los Angeles International Airport and designed some of Los Angeles County's most iconic buildings. Wong rarely designed residential houses, but he made an exception for his father-in-law, who owned Tom Lai's restaurant. (Courtesy of Grant Yee.)

This tapestry brick bungalow at 4104 Ingalls Street and West Lewis Street was the boyhood home of former state senator James Mills (born 1927). Mills served in the California State Senate from 1971 to 1980. He sponsored the Mills Act, legislation that permits owners of historically designated buildings to lower their property taxes in exchange for restoring and maintaining their historical sites. Senator Mills is a historian, author, and preservationist.

ABOUT EFFORTS TO INTERPRET CALVARY PIONEER MEMORIAL PARK

Community fundraising efforts are underway to better interpret the site of Calvary Cemetery (1873–1970), now Calvary Pioneer Memorial Park. Calvary Cemetery is City of San Diego historic site no. 5, and it is the final resting place of many of the city's founders and pioneers. The cemetery was converted into a park in the early 1970s. Efforts are underway to add signage for the park with an interpretive explanation to describe the previous use as a cemetery, acknowledge the founders of San Diego who are buried here, and explain its transition into its current use as a park. Join the authors in this endeavor by contacting them through Powers Plumbing, at 1705 West Lewis Street, or by calling (619) 295-2115. Visit www.BestSanDiegoPlumber.com/about/power-walks for more details.

Peter O'Malley is shown here around 1943 just outside the Works Progress Administration adobe wall that surrounded the border of Calvary Cemetery. (Courtesy of Rose Beyerle.)

4-2-2015

DISCOVER THOUSANDS OF LOCAL HISTORY BOOKS
FEATURING MILLIONS OF VINTAGE IMAGES

Arcadia Publishing, the leading local history publisher in the United States, is committed to making history accessible and meaningful through publishing books that celebrate and preserve the heritage of America's people and places.

Find more books like this at
www.arcadiapublishing.com

Search for your hometown history, your old stomping grounds, and even your favorite sports team.

Consistent with our mission to preserve history on a local level, this book was printed in South Carolina on American-made paper and manufactured entirely in the United States. Products carrying the accredited Forest Stewardship Council (FSC) label are printed on 100 percent FSC-certified paper.

MADE IN THE

USA